Belief and Modernism:
The Paintings of Father Péter Prokop at Our Lady of Hungary Parish

Belief and Modernism:
The Paintings of Father Péter Prokop at Our Lady of Hungary Parish

JAMES HOUGHTON

To Charlene
with regards
Enjoy the book
Jim Houghton

From the Prairie Publications, Inc.
South Bend, Indiana

From the Prairie Publications, Inc.
3101 Mishawaka Avenue
South Bend, IN 46615

From the Prairie Publications, Inc. books are available at quantity discounts with bulk purchase of educational, business, or sales promotional use. For information, write to:

Special Sales Department
From the Prairie Publications, Inc.
3101 Mishawaka Avenue
South Bend, IN 46615

Front and back book covers by Miguel A. Quijada of
MQ Graphic Design Solutions

Photographs of Father Prokop's triptych and frescoes at Our Lady of Hungary Church
by Steve Toepp of Midwest Photographics

Library of Congress Control Number: 2016944121

Printed in the United States of America
ISBN-13: 978-0-9972817-2-9
ISBN-10: 0997281723

This book is dedicated to my wife, Celeste; to my father, James, and to the memory of my mother, Margaret

This book is also dedicated to the memory of Katherine Sabo Graham who was central to Father Prokop's artwork at Our Lady of Hungary Catholic Church

Acknowledgements

I could not have written this book without the help, encouragement, and support of Father Kevin Bauman, pastor at Our Lady of Hungary Church and Ms. Kathy Baugher, the parish secretary, who provided much information about the parish's history. Also, I would like to thank Dean Marvin Curtis of the Raclin School of the Arts at Indiana University South Bend, who was instrumental in procuring a grant for the publication; Michael Snyder, my editor, whose commitment and exactness made my manuscript more readable; Steve Toepp, for his beautiful photographs, and Francisco Macias who helped us move a number of objects (one particular object was very heavy!) that made it possible for Mr. Toepp to photograph the art.

I owe many thanks to Joseph and Teresa Bella for providing translations from Hungarian to English and much firsthand information about the plight of refugees fleeing Hungary at the time of the uprising. I also would like to thank Linda DeCicco for seminal help, as well as John and Michele Kovatch and Nancy Kovatch DiLullo for much information about Father Prokop, his working methods in creating his art, and his joy for life. I would also like to thank Ilona Sabo Ross, Lani Sabo Worthington, and John Sabo, who aided in research, providing resources and information about Father Prokop, his art, and his love for soccer and life.

In addition, I would like to thank Marjorie Schreiber Kinsey, Ph.D., who first read the manuscript, for her always helpful insights and analysis; Brian MacMichael, M.A., Director of the Office of Worship for the Diocese of Fort Wayne-South Bend, whose suggestions especially in the area of theology, greatly improved the book; and Joan M. Downs, Ph.D., whose insights helped to strengthen my interpretation of the interdependence of art and Hungarian Catholic culture.

This book could not have evolved into its present form without the cooperation of David Graham, husband of Katherine Sabo, Stephanie Graham, Katherine's daughter, and Alex Townshend, Katherine's son, who made it possible for us to use Father Prokop's painting of Katherine in this book. I owe them much gratitude.

TABLE OF CONTENTS

FIGURES

Foreword

I had several purposes in writing this book. The first and foremost is to make the paintings at Our Lady of Hungary Catholic Church better known. When I saw the paintings for the first time in the summer of 2014, I was overwhelmed by the power of the color, simplicity of design, and evident sincerity of the message. I know of no other church imagery in the South Bend area that combines religious message and modernistic style on such a grand style. Second, my focus has been on the iconography, which is the study of the subjects, and the narratives and symbols and their possible meanings within Roman Catholicism and Hungarian cultural identity. Third, I refer to Father Prokop's style, or his knowledgeable and skillful blending of different traditions of art and melding those traditions with the modernism of early to mid-20th century European painting. Finally, though the book is directed toward the general reader and not the specialist in art, I have taken care to give the reader sufficient, though hardly exhaustive, sources upon which I based my thinking. Hopefully, these sources will assist readers who wish to pursue their own independent research.

Prelude

Upon entering Our Lady of Hungary Catholic Church, the viewer will see paintings in the sanctuary whose bright colors, decorative modernism, and sheer scale strike the eye, overwhelm the mind, and uplift the spirit. At first glance, the paintings, which consist of a large oil-on-wood triptych above the altar and a series of frescoes that cover the walls of the sanctuary,[1] seem to have no unified meaning. The paintings at Our Lady of Hungary Church comprise a number of distinct compositions, which include familiar canonical personages, events, and themes such as the Virgin and Child. However, other images are not understandable unless the viewer is familiar with Hungarian history and culture, both in Europe and in the United States. Without this background, the paintings seem to have little coherent meaning. We may best say that the paintings at Our Lady of Hungary Church present a coordinated imagery that depicts Catholic beliefs and Hungarian-American culture.

The Hungarian Catholic experience provides a context to help understand the paintings at Our Lady of Hungary. The 100 years from 1820 to 1920 may be seen as the great period of immigration from Europe to the United States. Over time, the nationalities and patterns of Catholic immigration changed.[2] Before the American Civil War, the Irish and Germans were the two major Catholic immigrant groups. After the American Civil War, numerous other ethnic Catholics from Southern and Central Europe came. Numerically, the Hungarians were among the smallest of these immigrant groups. They started coming between 1848 and 1867 due to the unsettled times in Hungary.

Most of the immigrants settled in the area defined by the cities of Boston, Philadelphia, St. Louis, Milwaukee, and the great industrial heartland of the East and Midwest. Most resided in urban areas. Though Indiana had no large cities, such as the burgeoning Chicago or Cleveland, the state participated in this great movement of peoples.[3]

1 In an April 14, 2014, conversation, Father Kevin Bauman, pastor at Our Lady of Hungary Church, said that all records pertaining to Father Prokop's time in South Bend have been lost. The Diocese of Fort Wayne-South Bend has few records that refer to either Father Prokop or the commission. As a result, very little documentation exists to shed light on the paintings.

2 Jay P. Dolan, *The American Catholic Experience. A History from Colonial Times to the Present* (Notre Dame, IN and London: University of Notre Dame Press, 1992), 127–157.

3 L.C. Rudolph, *Hoosier Faiths: A History of Indiana's Churches & Religious Groups* (Bloomington: Indiana University Press, 1995), 603–620. Though focusing on the Poles in South Bend and not on Hungarians, Rudolph, notably 612–618, discusses the centrality of the church in the lives of working people.

The patterns of Catholic immigration to Indiana generally mirrored the national pattern.

The C.S.C. (Congregatio a Sancta Cruce [Congregation of the Holy Cross]), under the direction of Father Sorin (1814–1898), founded St. Joseph's Catholic Church in South Bend in 1853. Irish and German immigrants were instrumental in establishing St. Patrick's in 1858. The Polish, the largest group of immigrants in South Bend, established St. Hedwig in 1877; St. Casimir's was dedicated in 1899, St. Stanislaus was dedicated in 1900, and St. Adalbert's in 1911.[4] There are other examples of ethnic Roman Catholic churches in the area, such as the Belgians in neighboring Mishawaka, whose church, St. Bavo's, was dedicated in 1903.[5] In short, immigrants wanted a Catholic church that was sensitive to their national and cultural backgrounds.

Like the Poles, the Hungarians settled on the west side of South Bend and built their first parish church, St. Stephen's, in 1883. By 1916, Our Lady of Hungary was established as a mission church of St. Stephen's to accommodate Hungarians who lived on the southwest side of South Bend. Father Paul Miller, a C.S.C. priest from the University of Notre Dame, came weekly to administer the sacraments until the first permanent pastor was appointed in 1921. This close relation between Notre Dame and Our Lady of Hungary was echoed throughout many churches in the South Bend area since the C.S.C. provided priests to numerous churches throughout northern Indiana and into southern Michigan.[6]

The Hungarians, as did many other immigrants, came to South Bend seeking work. Many were unskilled laborers, who had migrated throughout Europe before they came to the United States in search of work, willing to take the most dangerous and lowest paid jobs. Among other companies, Hungarians, like other ethnics in South Bend, worked for Oliver Chilled Plow Works, Singer Sewing Machine Co., Wilson Brothers Shirt Co., Studebaker, and other national and local firms. In many ways, their experiences mirror those of other ethnics: life was built around the church, neighborhood and cultural associations, and ethnic businesses.[7]

By 1920, new government restrictions on America's Open Door policy ended the great immigration period. However, after the 1956

 4 Rudolph, *Hoosier Faiths: A History of Indiana's Churches & Religious Groups,* 613–615.

 5 John F. Noll, *The Diocese of Fort Wayne, II,* 1941, 317.

 6 Rudolph, *Hoosier Faiths: A History of Indiana's Churches & Religious Groups,* 30.

 7 Darlene Scherer (researcher) and Karen Rasmussen (ed.), *Hungarian Americans of South Bend,* Ethnic Heritage Studies Program (Indiana University South Bend, 1975), 2–8.

revolution in Hungary, many people fled the country and were welcomed in the United States. Scherer and Rasmussen estimated that South Bend and Our Lady of Hungary parish helped about 300 refugees.[8]

Celebrating Hungarian culture, the artist Father Péter Prokop (1919–2003) completed the paintings at Our Lady of Hungary Church within a six-month period in 1961. The effect Father Prokop achieved through these intensely bright and monumental paintings, which is irresistible, elevating, and inspiring, is derived from centuries-old Central European painting tradition.

Studies in the history of art may concentrate on the study of subjects, that is, themes and their meanings, or on how the artist expresses his ideas, that is, style. This introductory book is primarily an explanation of the subject matter and the meaning of the paintings within the context of Catholicism and Hungarian ethnicity. Father Prokop's style is discussed as it illuminates in the expression of his ideas and interpretations of the subjects explored. While we can talk of subject, style, and context, perhaps the words of Father Prokop himself when he describes his painting as "visual preaching" should be our most direct, clear, and best guide to understanding his paintings at Our Lady of Hungary Catholic Church.[9]

8 Scherer and Rasmussen, *Hungarian Americans of South Bend*, 3–20.

9 Erika Papp Faber, "Prokop, Péter: Priest-Artist," *Magyar Studies of America: Magyar News Online,* June 2016, Issue 100, http://magyarnews.org/news.php?viewStory=1679.

Chapter I
A Need for Decoration

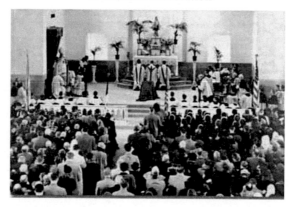

Figure 1: December 18, 1949, Dedication Mass at Our Lady of Hungary Church[1]

Our Lady of Hungary Catholic Church parish, in South Bend, Indiana, was founded in 1916. The original church structure was built the same year. After housing the congregation for more than 30 years, it was demolished in 1948, and ground was broken for the present structure. The Chicago architectural firm Herman J. Gaul and Son designed the new church as a hall church, which is a floor plan with a broad, open nave having no architectural obstructions to block the worshipper's view of the sanctuary. Though the new church was not yet finished, Bishop John Francis Noll headed numerous prelates who dedicated it with a solemn Mass on December 18, 1949.[2] The congregation began holding parish services one week later on Christmas Day.[3]

A photograph of the dedication mass (Figure 1) indicates that the interior walls of the new church, including those of the sanctuary, were painted white.[4] Evidence found in the parish's 1949 annual report, though scant, might lead the reader to believe that Father, lat-

1 Our Lady of Hungary Catholic Parish and School, 2014, Our Church History..., http://ourladyofhungary.com/church/churchhistory.htm.
2 "Church Ready for Dedication," *South Bend Tribune* (December 15, 1949), section 2, 6.
3 Our Lady of Hungary Catholic Parish and School, 2014, http://ourladyofhungary.com/church/churchhistory.htm. See also Jill Boughton, "Our Lady of Hungary: Bringing People Together in Three Languages," *Today's Catholic* (March, 21, 1993), 11–14.
4 Our Lady of Hungary Catholic Parish and School, 2014, http://ourladyofhungary.com/church/churchhistory.htm. See also *Our Lady of Hungary Church 1949* (*Magyarok Nagyasszonya Hitközség*), 7.

er Monsignor, John Sabo (1905–1991),[5] pastor of the church (1935–1980), was already thinking about the future decoration.[6]

Apparently, Msgr. Sabo wanted paintings in the new structure that would reflect the traditional decoration he saw in Hungarian and Central European churches, where it is not unusual to see a church with a plain exterior that opens into an interior decorated with coordinated paintings, sculptures, and other objects that create an effect that can be visually overwhelming.[7] Similarly, a number of parishioners have thought that the exterior of Our Lady of Hungary Church is austere, unadorned, and does not hint at the stunning interior decoration.[8]

In 1961, Msgr. Sabo commissioned Father Prokop to paint a triptych over the main altar. The sheer scale of the triptych suggests that Sabo already had procured the oak frame by the time the artist arrived in South Bend. Inspired by his love for Michelangelo's Sistine Chapel paintings, Msgr. Sabo wanted Father Prokop to fresco the sanctuary walls. Unfortunately, South Bend's cold, damp climate is not conducive to fresco painting, which could lead to staining and flaking. However, at Msgr. Sabo's insistence, workmen built a metal lath wall, which was then plastered over the existing sanctuary walls. This created an air space that allowed air to circulate and insulate. South Bend resident John A. Brown, a master craftsman and member of the Plasterers' Union, worked with Father Prokop while the priest executed his work at the church.[9] Though it would seem that the church would be unusable during the period Father Prokop painted, services continued—even with the scaffolding in place.[10]

When visiting Rome, Msgr. Sabo met Father Prokop whom he invited to decorate the interior of the new church. Father Prokop arrived in South Bend in early March 1961. He likely completed the paintings by November 1961, the year the triptych is dated. In a November 19, 1961, letter to Bishop Leo Pursley, Msgr. Sabo wrote, "Rev. Péter

5 Throughout the rest of the book he will be referred to as Msgr. Sabo.

6 *Our Lady of Hungary Church 1949 (Magyarok Nagyasszonya Hitközség)*, 7.

7 Lockerbie, "Sermons Written in Paint," *South Bend Tribune*, 8–10. For an outside view of Our Lady of Hungary Church, see Our Lady of Hungary Catholic Parish and School, 2014, http://ourladyofhungary.com/church/churchhistory.htm.

8 Conversation with Our Lady of Hungary Church Secretary Kathy Baugher June 2, 2015.

9 Lockerbie, "Sermons Written in Paint," 8–10. Lockerbie's article is the main source for information about the paintings.

10 Conversation with parishioner Roseann Smorse, June 2, 2015. On February 29, 2016, Nancy Kovatch DiLullo confirmed that parishioners used the church at the time the scaffolding was up as did her brother John Kovatch in a February 27, 2016, conversation—both grew up in the parish. In a June 7, 2016, conversation, Mary Szekendi, who grew up in the parish, also confirmed that the church was used at this time.

Prokop who has been here for six and a half months has returned to his residence in Rome, Italy."[11] The parish reports for Our Lady of Hungary from May 1961 note, "Church decoration begun," and, in 1962, "Additional church decoration during the year"—however, there is no reference to exactly what these decorations were. Father Prokop's paintings were dedicated in 1962.[12]

The paintings were not well-received by parishioners.[13] Some thought the paintings looked more like panels from comic books than works appropriate for a church.[14] Many left Our Lady of Hungary for other parishes.[15] A parishioner who moved back to the parish after the paintings were completed was "stunned." However, as with most parishioners today, she now loves them.[16]

11 Written communication from Fort Wayne-South Bend Diocese Archivist Janice L. Cantrell, dated May 15, 2014.

12 Ibid.

13 June 7, 2016, conversation with Mary Szekendi, who noted that many were shocked, even outraged, because the imagery was not traditional.

14 Conversation with parishioner Roseann Smorse, June 2, 2015.

15 Conversation with Father Kevin Baumann, April 14, 2014.

16 Conversation with parishioner Mary Scharr, June 2, 2015.

Chapter II
The Artist: Péter Prokop

To understand the artist and his work, it is necessary to know about the cultural environment in which Péter Prokop lived and his artistic heritage. Born January 6, 1919, in Kalosca, Hungary, just months after the collapse of the Austro-Hungarian Empire, Prokop lived for many years in Italy before returning to an independent Hungary in 1999, where he died in 2003.

Prokop grew up in a rapidly changing country. Though best known today as the paprika capital of the world, the relatively small town of Kalosca, which is located approximately 88 miles south of Budapest and six miles from the Danube, still retains importance as a religious center since it serves as one of four arch-bishopric sees for the country.

Hungarian Nationalism

Figure 2: Present Day Hungary¹

Throughout much of the early to mid-19th century, the relation of Hungary to neighboring Austria was tumultuous. Austria, aided by <u>tsarist Russia, crushed</u> the Hungarian Revolution of 1848. Afterward,

1 Library of Congress, Geography and Map Division, http://www.loc.gov/item/95680056/#about-this-item.

Austria imposed a harsh dictatorship, reducing the former kingdom of St. Stephen to the status of a newly conquered province. Nevertheless, Hungary developed systems and traditions distinct from Austria that essentially created a special place within the empire. However, by the early 1860s, people recognized that this system was failing. In 1867, Hungary and Austria reached a settlement: Hungary achieved governmental independence from Austria in many areas, such as education and even language, while the Austro-Hungarian central government retained responsibility in common areas, such as foreign affairs, defense, and finance.[2] Throughout the 19th century, Hungary began to stress its ethnic heritage—particularly its language, history, and culture—to define national identity.

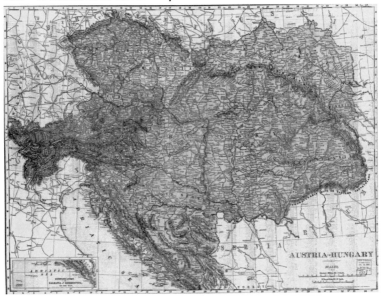

Figure 3: Austria-Hungary[3]

In World War I, Austria-Hungary fought alongside Germany against the Allied Powers (Allies) of the United States, the United Kingdom, France, and Russia. However, as early as 1918, before the end of World War I, the kingdom of Hungary had begun to fragment, with bordering states claiming and seizing territories.[4] Despite the Al-

2 Jörg K. Hoensch (tran. by Kim Traynor), *A History of Modern Hungary 1867–1986* (London and New York: Longman, 1988), 1–16.

3 Library of Congress, Geography and Map Division, https://www.loc.gov/item/2007627460/.

4 Hoensch, *A History of Modern Hungary 1867–1986*, 84–105.

lies' expressed intentions and U.S. President Woodrow Wilson's Four-
teen Points,[5] the Treaty of Trianon,[6] signed in 1920, formalized the
dismemberment of the traditional kingdom of Hungary, reducing it by
more than 70 percent in land area and by more than 60 percent in pop-
ulation (see Figure 4), with resultant decreases in natural resources,
industry, and societal cohesiveness. The Treaty of Trianon also isolated
Hungary, essentially leaving the country as an island in the midst of
hostile states. Hungary breached this isolation only in 1927 when it es-
tablished relations with Mussolini's Italy through the Italo-Hungarian
Treaty of Friendship and Arbitration.[7] The accord seems to have ori-
ented Hungary toward Italy, not only politically but culturally. In the
1930s, Hungary struggled to use its relationship with Italy against the
dominance of the more powerful Germany, but, nevertheless, in one
historian's felicitous phrase, became "Hitler's reluctant satellite."[8] As a
result of siding with Germany, the Russians savaged the country when
they invaded it in 1945.[9] After World War II, and following several
futile attempts, the communists established a one-party government.[10]
The October 1956 Hungarian rebellion against the system was crushed.
However, the communist government was finally ousted in 1989.

The national trauma created by the Treaty of Trianon is suggested
by the number of short-lived governments that quickly followed one
another until the conservative Miklós Horthy (1868–1957) was elected

5 Yale Law School, Lillian Goldman Law Library in memory of Sol Goldman,
The Avalon Project: Documents in Law, History and Diplomacy, "8 January, 1918: Pres-
ident Woodrow Wilson's Fourteen Points," http://avalon.law.yale.edu/20th_century/wil-
son14.asp.

6 "Treaty of Trianon. Treaty of Peace Between The Allied and Associated Pow-
ers and Hungary and Protocol and Declaration, Signed at Trianon June 4, 1920," http://
wwi.lib.byu.edu/index.php/Treaty_of_Trianon.

7 "Treaty of Friendship, Conciliation and Arbitration Between Hungary
and Italy. Signed at Rome, April 5, 1927," http://www.forost.ungarisches-institut.de/
pdf/19270405-1.pdf.

8 Dominic G. Kosáry and Steven Bela Várdy, *History of the Hungarian Nation*
(Astor Park, FL: Danubian Press, Inc., 1969), 260–281, argued that the results of the
Treaty of Trianon led to the alliance between Hungary and Italy and further asserted that
Hungarian policy during the 1930s may be seen as trying to cope naively and ultimately
unsuccessfully with the ever-increasing power of Germany. László Kontler, *A History of
Hungary: Millennium in Central Europe* (New York: Palgrave MacMillan, 2002), 355–56,
on the Hungarian-Italian relationship and 364–386, in which he discusses Hungary's
relation with Germany, which he succinctly captures in his heading, "Hitler's Reluctant
Satellite."

9 Hoensch, *A History of Modern Hungary 1867–1986*, 158–163. Kosáry and
Várdy, *History of the Hungarian Nation*, 292.

10 Hoensch, *A History of Modern Hungary 1867–1986*, 164–187; Kontler, *A
History of Hungary*, 385–430; and Kosáry and Várdy, *History of the Hungarian Nation*,
294–323.

7

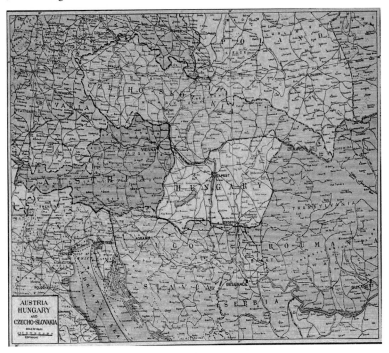

Figure 4: Hungary after the Treaty of Trianon[11]

regent in 1920, a post he refused to surrender until he was deposed in 1944. Beginning in 1938, Horthy successfully regained some territories lost under the Treaty of Trianon.[12]

The humiliation Hungary suffered under the treaty brought the country together, and it sought to reassert Hungarian uniqueness through appeals to the country's Magyar culture, historic traditions, and geographic position as the first defenders of Western European civilization against barbarian onslaughts from the East.[13] This reasser-

11 Library of Congress, Geography and Map Division, https://www.loc.gov/resource/g4153pm.gla00094/?sp=145.

12 Hoensch, *A History of Modern Hungary 1867–1986*, 137–150. The most telling examples of the changes in the Hungarian state are the two maps found in Hoensch, *The Kingdom of Hungary before 1920*, 21, which show the kingdom of St. Stephen and its reduction by the Treaty of Trianon and Hungary after World War I, with territories secured from 1939–1941. See Kosáry and Várdy, *History of the Hungarian Nation*, 217–227, which, analyzes the immediate events leading up to and the effects of Trianon. Kontler, *A History of Hungary*, 344. (See footnote 6 for link to the treaty's text.)

13 Hoensch, *A History of Modern Hungary 1867–1986*, 102–104. Kontler, *A History of Hungary*, 344. Kosary and Várdy, *History of the Hungarian Nation*, 217–227. See also Steven Bela Várdy, *Clio's Art in Hungary and in Hungarian-America* (East European Monographs Distributed by Columbia University Press No. CLXXIX), 171–198. For an

tion of national self-importance had a direct impact on the visual arts as taught and developed in Hungary.

During Prokop's childhood, until about 1930, Hungarians were among the leading and most innovative artists of the European avant-garde. Hungarian avant-garde artists were inspired by and worked alongside artists in the leading art centers, such as Paris and Berlin, but within Hungary, they used avant-garde ideas to interpret traditional subjects and themes anew.[14] These twin ideas of Hungarian identity and changing artistic ideas can be seen in Father Prokop's paintings at Our Lady of Hungary Church.

Traditionalism and Nationalism

By about 1930, both a more conservative society and government strongly influenced the visual arts. The government and official art circles discouraged the innovation associated with the avant-garde. As a result, many progressive artists, critics, and art historians left Hungary permanently for Western Europe and even for the United States. However, some avant-garde artists who left Hungary for the West returned and lived and taught in Budapest.[15]

The government and the academics, including those at the Budapest Academy of Fine Arts, explicitly rejected the modernist stress upon the abstract, the expressionist, and the surreal. As such, the Hungarian government and academic elite redirected the training of young artists toward a traditional realism in style and moral narrative in content.[16]

The Hungarian government encouraged young artists to emulate traditional Italian artists, such as those grouped under the name *Novecento Italiano* (Novecento), when, in 1927, it established the Academy of Hungary in Rome (the Academy). Born in Milan in 1922, Novecento quickly grew to have an international following, yet by

antithetical viewpoint, see Oscar Jászi, "Kossuth and the Treaty of the Trianon," *Foreign Affairs* (Oct 1933, Vol. 12, Issue 1), 86–97.

14 S.A. Mansbach, *Standing in the Tempest, Painters of the Hungarian Avant-Garde 1908–1930* (Santa Barbara, CA: MIT Press and the Santa Barbara Museum of Art, 1991), 46–74. S. A. Mansbach, "Confrontation and Accomodation in the Hungarian Avant-Garde," *Art Journal* (XXXXVIIII, Spring 1990), 9–20. "Activists," Grove Art Online, Oxford Art Online, Oxford University Press, http://www.oxfordartonline.com/subscriber/article/grove/art/T000384, and Philip Cooper, "MA group," Grove Art Online, Oxford Art Online, Oxford University Press, http://www.oxfordartonline.com/subscriber/article/grove/art/T053170.

15 Mansbach, *Standing in the Tempest, Painters of the Hungarian Avant-Garde, 1908–1930*, 228–238.

16 Ibid., 15–19.

about the early 1930s the movement had so broadened in sheer numbers its influence dissipated.[17] Though Novecento is often associated with Italian fascism, Benito Mussolini (1883–1945) seems to have favored, to a certain extent, nonintervention in the fine arts.[18] Originally, the artists of the Novecento rejected modernist movements, ideas, and trends in art[19] and sought to revitalize modern Italian art based on ideas and interpretations learned from the achievements of earlier great periods, styles, and masters. Hungarian artists who absorbed Novecento lessons achieved success in Italy.[20] In short, Hungarian artists rejected the madness of modernism found in Paris to accept the comfort of traditionalism found in Rome.

Prokop's teacher, Béla Kontuly (1904–1983), belonged to this select and influential group of young artists.[21] He studied at the Academy from 1928 to 1930.[22] The conscious adaptation of the Italian revivalism led to the establishment of the Academy, arguably one of the most important events in Hungarian art during the 1930s.[23] The artists who influenced Kontuly ranged from Italian masters of the 13th and 14th centuries to contemporary artists, including Ubaldo Oppi (1889–1942), who was associated for a time with the Novecento.[24] Oppi's derivative traditionalism is seen in the painting *I Pescatori di Santo Spirito* (*The Fishermen of the Holy Spirit* [1924]).[25] Art historian Matthew Gale has described Oppi's early work as having great exactitude.[26] It could even be described as being photograph-

17 Francis Monotti, "Young Italy Speaks," *New York Times*, June 23, 1929. Monotti's article is also an excellent summary of Novecento ideas.

18 Simonetta Fraquelli, "Novecento Italiano, Grove Art Online, Oxford Art Online, Oxford University Press, http://www.oxfordartonline.com/subscriber/article/grove/art/T062914. Fraquelli notes that Mussolini "acknowledged the relation of culture to politics but declared 'far be it from me to encourage something which could be identified as State art.'"

19 Ibid.

20 Ivan T. Berend, *Decades of Crisis* (Berkeley, Los Angeles, and London: University of California Press, 1998), 394.

21 Ernö Marosi, et al., "Hungary," Grove Art Online, Oxford Art Online, Oxford University Press, http://www.oxfordartonline.com/subscriber/article/grove/art/T039443.

22 "Kontuly," Magyar Katolikus Lexikon, http://lexikon.katolikus.hu/K/Kontuly.html.

23 Lajos Németh, *Modern Art in Hungary* (Budapest: Corvina Press, 1969), 75–81. Antal Kampis, *The History of Art in Hungary* (Budapest: Corvina Press, 1986), 330–331.

24 "Oppi, Ubaldo," *Allgemeines Künstlerlexikon: Die bildenden Künstler von der Antike bis zur Gegenwart*, XXVI, (Leipzig: Veb. E. A. Seeman Verlag, 1970), 33. Also "Oppi, Ubaldo," *Benezit, Dictionary of Artists*, X (Paris, Gründ, 2006), 625–626.

25 Bridgeman Images, *Fishermen of the Holy Spirit* (Oil on Canvas), http://www.bridgemanimages.com/en-GB/asset/702941.

26 Matthew Gale, "Oppi, Ubaldo," Grove Art Online, Oxford Art Online, Oxford University Press, http://www.oxfordartonline.com/subscriber/article/grove/art/T063656.

ic. Oppi painted frescoes, including a series in the Chapel of St. Francis, in Il Santo, Padua, that illustrate episodes from the life of St. Francis of Assisi, which Gale considers seminal to the development of mural painting in the 1930s.[27] Though there was a strong tradition of wall painting in Hungary, perhaps partially under the influence of Oppi, Kontuly and his student Prokop painted frescoes. With its emphasis on traditional artistic training and on the revivalist Italian aesthetics of the Novecento, the Hungarian government encouraged a traditional training in realistic drawing and painting. The Roman Catholic Church supported these traditionally trained artists, including Kontuly and Prokop, through commissions for churches, schools, and other religious-affiliated buildings.[28]

Tradition, Nationalism, and the Church

During Péter Prokop's youth, visual arts in Hungary were characterized by tradition, nationalism, and church patronage. It was within this continuing conservative artistic tradition that Prokop received his academic training.[29]

After attending local schools and the Jesuit seminary, Prokop was ordained on March 25, 1942.[30] Though recognized early as having a talent for art, it was in 1945 that he began formal art studies with Béla Kontuly,[31] and several other teachers, at the Fine Arts Academy in Budapest. Though Prokop studied with the conservative Kontuly and other traditionalists, he was certainly aware of

27 Images (unfortunately black and white) can be found of 12 frescoes from the life of St. Francis at Alinari, Archives, http://www.alinariarchives. it/en/search?isPostBack=1&panelAdvSearch=opened&artista=Oppi,%20Ubaldo%20%281889-1946%29. Gale, "Oppi, Ubaldo," Grove Art Online, Oxford Art Online, Oxford University Press, http://www.oxfordartonline.com/subscriber/article/grove/art/T063656. For a color representation, see Victor M. Parachin, "Christmas with St. Francis,: *Messenger of St. Anthony*, " http://www.messengersaintanthony.com/messaggero/pagina_articolo.asp?IDX=529IDRX=144.

28 Berend, *Decades of Crisis*, 394.

29 Ibid., 393–395.

30 Kalocsai Érseki Kincstár, Prokop Péter életútja 1919-2013 (Prokopp Mária könyve alapján), "A kezdetek (1919-1942)," http://kincstar.asztrik.hu/?q=content/a-kezdetek-1919-1942. Erika Papp Faber, "Prokop, Péter: Priest-Artist," *Magyar Studies of America: Magyar News Online*, June 2016, Issue 100, http://magyarnews.org/news.php?viewStory=1679.

31 Kontuly studied at Prague and Budapest, and was a fellow at the Hungarian Academy in Rome from 1928 to 1930. He was influenced by masters of the early Italian Renaissance and contemporary artists, including, notably, Ubaldo Oppi (1889–1942), who was associated for a time with the Novecento, and Felice Casorati (1883–1963), who, though not part of the Novecento, was a traditionalist artist.

and appreciated Hungarian avant-garde artists. Maria Prokopp notes that he also greatly admired the paintings of avant-garde artist Tivadar Csontváry Kosztka (1853–1919), whose paintings seem magical, even mystical.[32] From 1947, when Prokop received his earliest commissions, until the time he left Hungary, he executed paintings and frescoes for churches, often in his native southern Hungary. Prokop's most accomplished fresco seems to have been his *Last Judgment* painted at All Saints Church in Sükösd[33] in 1950. One art historian compared Prokop to the earlier church painter, Vilmos Aba-Novák (1894–1941), notably his famed Jászszentandrás paintings,[34] stressing that Prokop was the first artist since Aba-Novák to achieve such a high level of originality, sincerity, and freshness that could make Hungarian ecclesiastical art prosper.[35]

After the Hungarian Revolution (October 23–November 10, 1956), Father Prokop left Hungary, arriving in Rome, in 1957, possibly by spring.[36] From 1957 to 1961, he studied painting at the Academia delle Belle Arti, in Rome, with Cipriano E. Oppo (1891–1962)[37] who had exhibited with Novecento at least once, in 1922.[38] It was at this time that Msgr. Sabo first saw Father Prokop's work at the Hungarian Pontifical Institute in Rome, and invited him to decorate

32 Mansbach, *Standing in the Tempest, Painters of the Hungarian Avant-Garde 1908-1930*, 101–103, 229, lists a number of avant-garde artists, who often had left Hungary in the 1920s and 1930s, but had returned home, usually to Budapest, by the time Prokop was studying at the Budapest Academy of Fine Arts. See Kalocsai Érseki Kincstár, Prokop Péter életútja 1919-2013 (Prokopp Mária könyve alapján), "Elsö állomáshelyei, müvészeti tanulmányok a Képzömüvészeti Föiskolán (1942-1949)," http://kincstar. asztrik.hu/?q=content/elso-allomashelyei-muveszeti-tanulmanyok-a-kepzomuveszeti-foiskolan-1942-1949. Maria Prokopp describes Csontváry's style as magical and expressive. Also see Bridgeman Images, *Pilgrimage to the Cedars of Lebanon*, 1908 (oil on canvas)," http://www.bridgemanimages.com/en-GB/asset/853741.

33 See Sükösd, "Prokop Péter És a Híres Sükösdi Falfreskó," http://www.sukosd. hu/?module=news&action=show&nid=63370.

34 See images of Vilmos Aba-Novak's paintings at Jászszentandrás at http:// www.geocaching.hu/images.geo?id=54869&group=4445&table=cache_images&wi=600&he=445.

35 Kalocsai Érseki Kincstár, Prokop Péter életútja 1919-2013 (Prokopp Mária könyve alapján), "Az elsö megbizatások (1947-1956)," http://kincstar.asztrik.hu/?q=content/az-elso-megbizatasok-1947-1956.

36 Ibid., in which Maria Prokopp wrote that Father Prokopp fled through Yugoslavia. In an October 2015 conversation with Joseph and Teresa Bella, refugees from the 1956 revolution, Mr. Bella, who provided the translation to Maria Prokopp's Hungarian text that was used in this footnote, noted that Hungarians who fled through Yugoslavia were often sent at least temporarily to prison camps.

37 "Oppo, Cipriano Efisio," *Allgemeines Künstlerlexikon: Die bildenden Künstler von der Antike bis zur Gegenwart*, XXVI, 34. Also "Oppo, Cipriano Efisio," *Benezit, Dictionary of Artists*, X, 626–627.

38 "Oppo, Cipriano Efisio," *Benezit, Dictionary of Artists*, X, 626.

Our Lady of Hungary Church. Father Prokop accepted the offer as a way to thank Our Lady of Hungary parishioners for aiding Hungarian refugees after the aborted 1956 Hungarian uprising.[39]

Prokop's Style

Despite his training by traditionalist masters, Father Prokop's paintings differ from those of his teachers, either the Hungarian Kontuly, or the Italian Oppo. Kontuly's paintings, from the 1930s, both religious and secular, seem trite and saccharine. For example, *Friends*[40] displays, at best, a limpid clarity of space, sharpness of outline, and muted color, all derived from a superficial understanding of Italian 14th- and 15th-century masters. Oppo may have attempted to understand the lessons of earlier Italian art, but he created little that demonstrated an imaginative originality. Oppo's work can best be described as an undemanding and facile realism.[41] At the same time, Father Prokop's work cannot be described as progressive when compared to cutting-edge American art created in the early 1960s.

After World War II, when the center of the art world shifted from Europe to New York, styles evolved radically and quickly. Compared to such movements as American abstract expressionism, pop art, and minimalism, Father Prokop's paintings seem dated. However, they do not fall easily into the conservative, traditional trend of 1930s and 1940s Hungary. Though Prokop does paint traditional Roman Catholic subjects—the main figure on the triptych at our Lady of Hungary Church is readily identifiable as the Virgin Mary—he is innovative in how creatively he expresses them.

In the paintings at Our Lady of Hungary Church, Prokop blends distinct artistic styles—what may be defined as traditional and is exemplified by his awareness of Byzantine icon painting, mosaic, and Medieval stained glass. Broadly, these are characterized by a sense of geometry seen, for example, in the figures that seem formal and controlled, which are often presented frontally, on a large scale, and that seem two-dimensional, existing in flat, non-illusionistic space.

39 Scherer and Rasmussen, *The Hungarian-Americans of South Bend*, 3–20. According to Scherer, in 1956, an estimated 300–320 Hungarians arrived in South Bend. Lockerbie, "Sermons Written in Paint," *South Bend Tribune*, 9, notes that Prokop came to South Bend "in part due to gratitude for aid given to fellow refugees by Our Lady of Hungary Parish."

40 MNG, Hungarian National Gallery, http://mng.hu/collection/friends-21120.

41 See Wikiwand, Basilica di Sant'Antonio di Padova, "Cappella di San Francesco," http://www.wikiwand.com/it/Basilica_di_Sant'Antonio_di_Padova.

Prokop was aware of European modernism. Besides his appreciation for Hungarian avant-garde artists such as Kosztka, Maria Prokopp writes of his deep admiration for the Swiss-German modernist artist Paul Klee (1879–1940), but her phrasing suggests he was more broadly aware of 20th century modernism.[42]

Prokop's style is a decorative blend of earlier 20th century art innovations and trends that characterized the European avant-garde. It is possible to point out his relation to, inspiration from, and use of ideas found in movements such as fauvism, cubism, and expressionism. The fauvists emphasized color, the cubists structure, and the expressionists distortion to express their ideas.[43] However, two ideas stand out. The first is Father Prokop's rejection of a strict mimesis or realism that is an exacting and detailed imitation of the natural world. The second is his acceptance of expression of idea through the abstracted artistic language of formal elements, particularly through color—above all discordant color—and to a lesser degree, the manipulation of shape and form.

42　Kalocsai Èrseki Kincstár, Prokop Péter életútja 1919–2013 (Prokopp Mária könyve alapján), "A nagy tanítómester: Róma, az elsö római év (1957)," http://kincstar.asztrik.hu/?q=content/a-nagy-tanitomester-roma-az-elso-romai-ev-1957.

43　Mansbach, *Standing in the Tempest, Painters of the Hungarian Avant-Garde, 1908–1930*, 228–238. Even an examination of just the artists included in this exhibition includes at least 14 avant-garde artists who lived and worked in Budapest about the time Prokop would have been a student. Several others worked in towns or areas outside Budapest. Among the paintings in the exhibition, there are representative studies of and influences from cubism (Imre Szobotka), fauvism (Vilmos Perott Csaba), and expressionism (Karoly Kernstock).

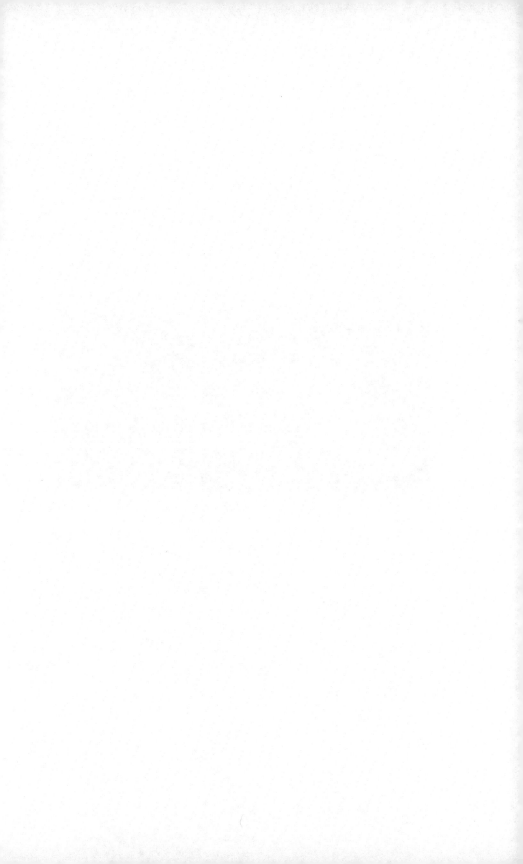

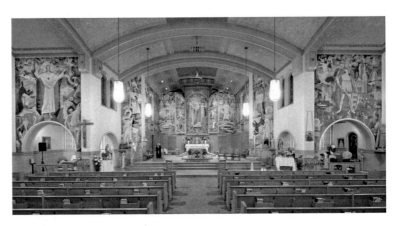

Figure 5: The Paintings

Chapter III
The Paintings

In many ways, the only clues to the meanings of the paintings at Our Lady of Hungary Church are the works themselves, since the few written references that document the ideas and intentions of Msgr. Sabo and Father Prokop are insufficient to provide a guideline. Since he commissioned the paintings, Msgr. Sabo must have been the driving force behind the program or subjects selected as well as the decorative scheme. Sarah Lockerbie noted that Father Prokop began working on the paintings the day he arrived,[1] which suggests that he and Msgr. Sabo had previously agreed on the subjects to be represented, their placement, and their interrelation. Father Prokop must have already executed preliminary compositions for the paintings and, perhaps, detailed drawings. Some, such as Mary as the patroness of Hungary, the inclusion of the Hungarian national saints, and the fresco of St. Emeric, would be expected in a Hungarian Roman Catholic church. However, even if Msgr. Sabo wanted these particular subjects, Father Prokop interpreted them within the context of post-World-War-II Hungary. Others, such as the Sacred Heart, are more universal and, therefore, less specifically identifiable with Hungarian culture. If, however, the different subjects suggest a certain disunity—a bringing together of disparate images—it is the style of Father Prokop that unites the paintings into a compelling whole.

While the faceted shapes of intense color are modernistic, this same quality of intense color is reminiscent of two much-earlier religious artistic traditions. The first tradition, the mosaic, is found in churches throughout Christendom from the earliest days of the Church. While Father Prokop did not use mosaic at Our Lady of Hungary Church, he later used the medium in a series of works he designed at St. Stephen's Hungarian Catholic Church, in Toledo, Ohio.[2] The second, the more familiar stained glass windows, with their luminous colors and broken shapes, seems even closer to the bright colors and large, geometric shapes of Prokop's paintings.

Father Prokop seems to have been aware of Byzantine or Orthodox imagery and traditions, since they seem to have served as sources for his paintings. One of the most accomplished Hungarian academic artists, Vilmos Aba-Novák (1894–1941), executed paintings in the village church of Jászszentandrás (located on the central

1 Lockerbie, "Sermons Written in Paint," *The South Bend Tribune*, 8–10.
2 Catholic Architecture and History of Toledo, Ohio, St. Stephen, East Toledo, January 30, 2008. catholictoledo.blogspot.com/2008_01_01_archive.html.

plains of Hungary) that clearly derive from Byzantine or Orthodox icons.[3]

The tradition of icons[4] is more closely associated with the Orthodox Church than with Catholicism and Western Christianity. Andreopoulos suggests four uses for icons: (1) to depict holy narratives, (2) to assist the faithful in prayer, (3) to suggest the presence of the depicted person, and (4) to connect humankind with the divine.[5] The sense of naturalism, the sense of formality, the sense of the archaic, the arrangement of figures in rows, and the intense color indicate that Aba-Novák closely studied historical icons. Prokop knew Aba-Novák's paintings since Aba-Novák taught Kontuly, who, in turn, taught Prokop.[6]

Furthermore, while the post-World-War-II international community thought an Iron Curtain divided Eastern from Western Europe, which may have applied most appropriately to politics and economics, this dogma ignored the history that bound East and West. Hungary's position as an important cultural crossroads is suggested through an examination of a current map (Figure 2). To the north, west, and southwest of Hungary, the countries of Slovakia, Austria, and Croatia are Roman Catholic. The countries to the east and south, Ukraine, Romania, and Serbia, are Orthodox. This area of Central Europe may be called a melting pot of nationalities, cultures, and religions. Because Hungary was at the crossroads, its artists, including those working for the Church, knew different traditions to present religious ideas. Prokop incorporated some of these ideas into the paintings at Our Lady of Hungary Church. A his-

3 Images of the paintings at Jásszentandrás may be found at http://www.geocaching.hu/images.geo?id=54869&group=4445&table=cache_images&wi=600&he=445. Andreas Andreopoulos, *Metamorphosis: The Transfiguration in Byzantine Theology and Iconography* (Crestwood, New York: St. Vladimir's Seminary Press, 2005), 24–36.

4 Dumbarton Oaks Research Library and Collection 75, The Uncovering of the Mosaics of Hagia Sophia in Constantinople: From a letter written to Mildred Barnes Bliss on October 11, 1936, http://www.doaks.org/library-archives/dumbarton-oaks-archives/royall-tyler-2013-excerpts-from-letters-about-his-travels/the-uncovering-of-the-mosaics-of-hagia-sophia-in-constantinople.

5 Andreopoulos, *Metamorphosis: The Transfiguration in Byzantine Theology and Iconography*, 26–27.

6 Thomas F. Mathews, *Byzantium From Antiquity to Renaissance, Perspectives* (New York: Harry N. Abrams, Inc, 1998), 43–52 discusses the combination of naturalism and formalism in icons. S. Kontha, "Aba-Novák, Vilmos," Grove Art Online, Oxford Art Online, Oxford University Press, http://www.oxfordartonline.com/subscriber/article/grove/art/T00005. Prokop Péter életútja 1919-2013 (Prokopp Mária könyve alapján), "A nagy tanítómester: Róma, az elsö római év (1957)," http://kincstar.asztrik.hu/?q=-content/a-nagy-tanitomester-roma-az-elso-romai-ev-1957. As Maria Prokopp notes, Father Prokop was a student of Kontuly, who was a student of Aba-Novák.

torical map of pre-Trianon Hungary shows that much of this territory was part of the kingdom of St. Stephen (see Figure 3).

Father Prokop's style is modernistic, but he used traditional methods to create the paintings. When working on a large-scale painting, such as what Father Prokop was doing at Our Lady of Hungary, an artist will follow a certain method or procedure. He or she begins by working out the composition and its details, such as poses of the figures, in small-scale drawings. Once satisfied, the artist will enlarge the small, finished composition to a full-size drawing called a cartoon. The artist then will pierce or punch holes in the finished cartoon and place it on the surface to be painted. He or she will use chalk or charcoal powder to make spots or dots on the surface. Having transferred the drawing to the surface to be painted, the artist removes the paper cartoon, connects the dots, and proceeds to paint.[7]

The Triptych

In his triptych, Father Prokop has combined the traditional in subject matter with an innovative style. Open, the center altarpiece shows the dominating figure of Mary (Figure 6).[8] The artist emphasized two different, though related, ideas about Mary in his painting: her role within traditional Hungarian culture and her role within the Roman Catholic faith.

Traditionally, Hungarians have seen themselves as being under the care of Mary, the special protector of Hungary (*Patrona Hungariae*). Early converts to Catholicism celebrated Mary's role as the protector of Hungary by adopting the pagan honorifics of *Boldogasszony* (Blessed Lady) or *Magyarok Nagyasszonya* (Great Lady of the Hungarians). The role of *Nagyasszonya* seems somewhat vague.[9] While the Marian ideas associated with these titles developed within a medieval Catholic society, by the 17th century, Hungarians, non-Catholic as well as Catholic, saw Mary as the Patrona Hungariae. She had been transformed from Catholic veneration to a national symbol. Hungarians saw her special inter-

7 In a February 27, 2016, conversation, John Kovatch indicated that Father Prokop laid out paper on the floor of the Our Lady of Hungary School gym to make full-scale drawings.

8 The central panel of the triptych, which shows Mary, the Christ child, and saints is approximately 21 ft. 7 in. tall x 10 ft. 8 in. wide. Each wing is approximately 5 ft. 4 in. wide.

9 Boldogasszony Patron Saint of Hungary, The Editors of Encyclopaedia Britannica, *Encyclopaedia Britannica*, http://www.britannica.com/topic/Boldogasszony.

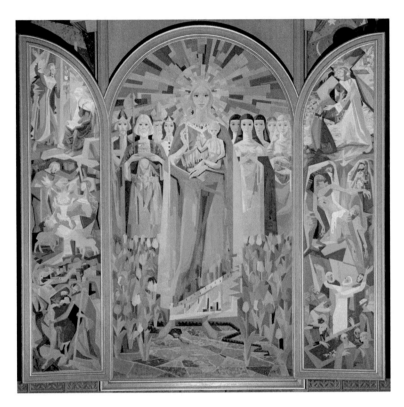

Figure 6: The Triptych (open)

vention throughout their history, as in the 17th century when they threw off Ottoman Turkish rule.[10]

In the triptych, Father Prokop emphasizes the importance of Mary. He uses hierarchical proportion, where the most important figure in the painting is the largest and grandest. Thus, as the viewer can readily see, in comparison to the other figures, Mary overwhelms because she is monumental and stands much closer to the picture plane or the front. His use of hierarchical proportion visually states her role as the Patrona Hungariae.

Prokop depicts Mary stepping on the serpent (Figure 7), a reference to Mary both as the Patrona Hungariae as well as the traditional depiction of her as the New Eve. Eve and Mary are similar in that both were created without the taint of original sin. However, numerous contrasts between Mary and Eve can be discussed. These include: (1) Eve was created from Adam, but the New Adam, or Christ, is born of Mary; (2) Eve disobeyed God when she listened to the serpent, but Mary accepted God's will when she listened to the archangel Gabriel; (3) Eve gave birth to earthly humanity, however, Mary gave birth to the means of salvation; and (4) Adam and Eve caused the fall of humankind whereas Christ, who was human and divine, with the cooperation of Mary, saved humankind.[11] In Father Prokop's triptych, Mary steps on the serpent, crushing it, but what spills forth from its mouth is a black hammer and sickle in a pool of blood. This is an effective and direct symbol, almost to the point of propagandistic simplicity, of the 1949 communist takeover of Hungary, and to the crushing of the 1956 uprising.[12] The symbolism is clear: while the triumph of a communist system might signal a temporary downfall, ultimately, Hungary, under the protection of Mary, will prevail.

Two important ideas need to be discussed about the way Father Prokop depicted Mary and the Christ child. First, he stressed the ul-

10 Ildikó Glaser-Hille, "Magyarok Nagyasszonya: The Virgin Mary as a Symbol of Hungarian National Identity," 16–18.

11 New Advent, Dialogue with Trypho (Chapters 89–108), Chapter 100: "In what sense Christ is [called] Jacob, and Israel, and Son of Man," http://www.newadvent. org/fathers/01287.htm. Ireneaus, Saint, Bishop of Lyon, *Five Books of St. Irenaeus of Lyons Bishop of Lyons Against Heresies* (Oxford, J. Parker, 1872), HathiTrust: 100337939, 294–95 and 494. New Advent, On the Flesh of Christ, Chapter 17, "The Similarity of Circumstances Between the First and the Second Adam, as to the Derivation of Their Flesh, An Analogy Also Pleasantly Traced Between Eve and the Virgin Mary," http://www.newadvent.org/fathers/0315.htm. See also Catholic Answers To Explain & Defend the Faith, Mary: "Full of Grace," www.catholic.com/tracts/mary-full-of-grace. This site offers a number of quotes from the Early Church Fathers about their conception of Mary, including as the New Eve.

12 The map shown in Figure 4 graphically demonstrates this dismemberment.

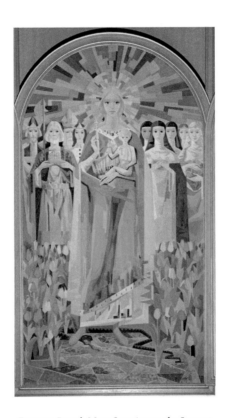

Figure 7: Detail: Mary Stepping on the Serpent

timate triumph of divine righteousness and power. Mary holds the Christ child, but they display little sense of affection: neither looks at the other and there is little sense of feeling or warmth between them. The lack of human affection between the two indicates that Prokop wanted to show them as regal or as divine rulers. Second, the size difference between Mary and the Christ child is somewhat disconcerting, and Father Prokop may have used it to suggest Mary's role as Patrona Hungariae as well as her traditional role as intercessor with Christ. The regality of the pair as well as the emphasis on Mary is not uncommon both in Roman Catholic and Orthodox art. Mary and the Christ child are reminiscent of Orthodox icons that stress a sense of the imperial in their depictions. From the time of St. Stephen, in the 11th century, Hungary was a crossroads between the Catholic West and the Orthodox East. Paintings, especially smaller icons, could easily be transported from the East. It should also be noted that the Byzantine style of painting greatly influenced the development of the pre-Renaissance of the late 13th century and the early Renaissance of the 14th century in Italy. Certainly, Father Prokop knew this tradition through his study in Italy.

Before discussing the saints, several other points about Mary should be clarified. She seems quite young,[13] which traditionally referred to her chasteness.[14] Also, she has startlingly bright red hair. While Mary seldom has hair that bright, it is not unusual for her to have hair that may be described as variations on reddish brown or auburn. Again, though it is traditional to see Mary dressed in a blue gown with a red cape, she is often depicted as dressed in other colors.[15] Father Prokop used the red garment to contrast Mary with the duller blues of the other figures. This brilliant color also serves to emphasize Mary by pushing her out of the triptych, into the viewer's space. This type of illusion was often used to bring the devotee into active contemplation or involvement with the saint depicted.

13 According to her cousins Ilona Sabo Ross and Lani Sabo Worthington (May 8, 2016, and May 2016 conversations) and her brother John Sabo (May 11, 2016, conversation), Katherine Sabo (1950-2014), niece of Msgr. Sabo, served as the model for Mary (Figure 8). Father Prokop painted a number of Msgr. Sabo's nieces' and nephews' portraits, and though they were quite young at the time, instead of painting them as they looked, he painted them as he thought they might look a few years in the future.

14 The central panel of the triptych (Figure 6), which shows Mary, the Christ child, and saints, is approximately 21 ft. 7 in. tall x 10 ft. 8 in. wide. Each wing is approximately 5 ft. 4 in. wide.

15 See, for example, the *Assumption of Mary* in the Kalosca Cathedral, which Prokop would have known since childhood. See Panoramio: Google Maps, Kalocsa, Nagyboldogasszony főszékesegyház belseje/St. Mary cathedral interior, http://www.panoramio.com/photo/58032892.

Finally, Mary contrasts with the other figures on the triptych because she has wide, open eyes while the other major figures have only darkened orbits.[16] Since Mary has eyes made prominent by the large sclera surrounding her pupil, the devotee or viewer concentrates upon her. Parishioners and other viewers of the triptych have sometimes wondered if Prokop wanted Mary's eyes to seem to follow them around the room.[17] Father Prokop not only seems to make Mary's eyes somewhat large, but his emphasis on the sclera creates a visual rapport between Mary and the viewer. Psychologists have pointed out that humans are the only primates with a white sclera, and have theorized that this may have enhanced communication.[18] Furthermore, do Mary's eyes symbolize that she is the only person who can see the glory of Christ? Whether there is any symbolism, it clearly is one more way that indicates Father Prokop wanted to emphasize Mary, her role in Christ's life, her importance in the history of Hungary, and her relation to the devotee. Prokop accentuated Mary's eyes for several reasons: (1) to emphasize her position in Catholicism and Hungarian history, (2) to stress her importance as source of meditation or inspiration for the faithful, (3) to suggest the veneration of the faithful as they honor the heavenly Mary through the painted image in the church, and (4) to unify the materiality of this world with the spiritual when the faithful pray.

While all the figures in the painting look outward and thus confront the viewer, Father Prokop used nationalistic symbols to connect Mary, the Christ child, and the saints with each other and with devotees. He did it by using four objects that traditionally symbolized royal authority in Hungary. First, Mary holds the scepter and second, in what seems to be a visual pun, wears the mantle, which is often associated with shawls or cloaks worn by women as well as with the idea of a cloak bestowed upon the assumption of leadership.[19] Third, the Christ child holds the orb.[20] Besides being a symbol of the legitimacy of Hungarian royal authority, the orb is also a symbol of the universality of Jesus Christ's message. Behind Mary, St. Stephen, the first king of Hungary, holds the fourth, and most important, symbol of Hungary:

16 A close look at the painting of the flight into Egypt on the left wing (Figure 6) reveals that St. Joseph and the donkey clearly have pupils.

17 In a conversation on June 2, 2015, with church Secretary Kathy Baugher, she noted that parishioners have thought this.

18 Hiromi Kobayashi and Shiro Kohshima, "Unique morphology of the Human Eye," *Nature* (6/19/1997), 767–768.

19 Glaser-Hille, "Magyarok Nagyasszonya: The Virgin Mary as a Symbol of Hungarian National Identity," 26.

20 An Introduction to the Hungarian Coronation Jewels, The Crown of Saint Stephen I, "The Orb," http://www.historicaltextarchive.com/hungary/jewels.html.

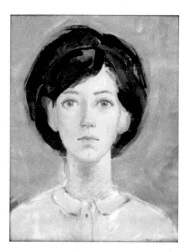

Figure 8: Katherine Sabo Who Served as the Model for the Virgin Mary in the Triptych
—Courtesy of painting's owner, David Graham, and photographer, Stephanie Graham

the Holy Crown.[21] Traditionally, it was believed to be a papal gift that legitimized Hungary and Hungarian rule and symbolized St. Stephen's allegiance to Catholicism and a rejection of both Byzantine Orthodoxy and the Holy Roman Empire.[22] Glaser-Hille summarizes the centrality of the crown to Hungarian life: even to this day all Hungarians are considered citizens of the Crown, which not only symbolizes the sovereignty of Hungary but is considered to be Hungary. The relation of land and the people to the Crown is seen in the various Hungarian descriptions including "Lands of the Hungarian Crown," "Lands of the Holy Crown of Hungary," "Crown Lands of St. Stephen," and "Lands of the Holy Crown of Hungary."[23] Furthermore, it was Stephen who created the identification of Hungary with Mary, when he offered his country to the protection of Mary. Glazer-Hille describes this offering as a coronation of Mary as Queen of Hungary, whereby the country became her property and Mary became identified with Hungary.[24] Hungarians refer to the kingdom of Mary (*Regnum Marianum*), which denotes Stephen's gift of the country to Mary and suggests the close connection between Hungary and Mary. As such, Glazer-Hille doesn't just describe a historical symbol of long standing: she describes a mystic gift of the earthly country to the Mother of God. In fact, she describes the role of Mary as present in Hungary as being similar to the sacramental presence of the Body of Christ in the Eucharist during Mass.[25] Her metaphor provides a structure for interpretation of the paintings.

Unless the ruler was enthroned with these symbols, he or she was not considered legitimate. Once again, Father Prokop has bound the religious and the cultural into a strong and pointed contemporary message: no government is legitimate if it is not invested with these traditional symbols. When Father Prokop painted the triptych, the Holy Crown was not in Hungary but in Fort Knox, Kentucky.[26] Therefore, the communist regime could not be legitimate.

21 Patrick J. Kelleher, *The Holy Crown of Hungary* (Papers and Monographs of the American Academy in Rome, vol. 13, Rome American Academy, 1951), especially 1–4 and 19–31, on the history and significance of the Holy Crown.

22 Nevertheless, Cecily Hilsdale convincingly argues that the corporeal crown is Byzantine in origin. See Cecily Hilsdale, "The Social Life of the Byzantine Gift: The Royal Crown of Hungary Re-Invented," *Art History*, 2008, http://onlinelibrary.wiley.com doi:10.1111/j.1467-8365.2008.00634.x/pdf, 602–631.

23 Steven Béla Várdy, *Historical Dictionary of Hungary* (Lanham, MD: Scarecrow Press, 1997), 337.

24 Glaser-Hille, "Magyarok Nagyasszonya: The Virgin Mary as a Symbol of Hungarian National Identity," 13–14.

25 Ibid., 13–14.

26 John M. Szostak (complied by Attila L. Simontsits), "America's Acquisition of St. Stephen's Crown," *The Last Battle for St. Stephen's Crown* (Toronto: Weller Publishing, 1983), 721–724.

Some of the figures behind Mary can be clearly identified. To the right of Mary, stands St. Stephen (Figure 6), and behind him are three other figures. Stephen was popular in his own right, but he achieved great historical and cultural importance because he Christianized Hungary and built numerous churches. He dedicated these churches to Mary, which in effect, dedicated the country to Mary as Patrona Hungariae, who then protected it from danger and evil.[27] The figures behind St. Stephen are a bishop, a soldier, and a woman.

Though the bishop holds no identifying symbols, two specific identifications may be possible. He may be St. Gellért. Born Gerard Sagredo in Venice (c. 980), he seems to have been on a very roundabout pilgrimage to Jerusalem when he met King Stephen in Hungary. The king invited Gellért to tutor his son Emeric, and several years later appointed Gellért archbishop to an open see. Pagans martyred him in 1046. This identification is further supported since Stephen, Emeric, and Gellért were all canonized on the same day. However, he could also be St. Astrik, whom St. Stephen sent to Rome as an ambassador to Pope Sylvester II. Shortly after his return, Astrik crowned St. Stephen with the crown the Pope had sent. This is consistent with St. Stephen holding the crown in the painting. Later, Stephen appointed him first archbishop of the Hungarian Church. While Kalosca was not the first archbishopric in Hungary, some believe Stephen appointed Astrik archbishop there. If, indeed, the figure does refer to Astrik, it brings together a reference to Hungarian culture with the presence of the Crown, and an extremely personal reference to Prokop, since he was born in Kalosca.

The soldier standing behind St. Stephen may be St. Ladislaus or Ladislas (1040–1095), who was known as a pious knight and king. The woman next to St. Stephen is his wife, Blessed Gisela (985–1065), since she wears what seems to be a crown. Though here she does not hold any symbol to identify her, in other depictions she often holds a church building to symbolize her efforts to help St. Stephen Christianize Hungary.

Some of the other female saints may be identified. On the left side of Mary is St. Elizabeth of Hungary (1207–1231), known for her works of charity and identifiable by the roses she carries. The nun next to her is probably her niece, St. Margaret of Hungary (1242–1271), who practiced a life of prayer and mortification. Both aunt and niece were canonized on the same day, November 19, 1943. Though the other figures lack symbols that would provide certain identification, Prokop

27 Glaser-Hille, "Magyarok Nagyasszonya: The Virgin Mary as a Symbol of Hungarian National Identity," 12.

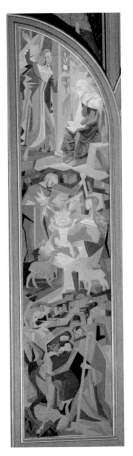 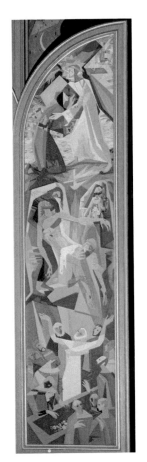

Figure 9: Left Wing of the Triptych *Figure 10: Right Wing of the Triptych*

presumably included them to represent the national saints of Hungary.

When the triptych is open, three scenes are depicted on the left wing (Figure 9 [top to bottom or to Mary's right]): the Annunciation, the Nativity, and the Flight into Egypt. In the Annunciation, the archangel Gabriel surprises Mary as she is reading and contemplating. Christ blessing at the Nativity is less common, since the Nativity was often used to stress the humanity of the baby Jesus. Christ seldom proclaims His divinity as He does here, though the shepherds and the wise men each recognize and submit themselves to it. The Flight into Egypt is more traditional; Mary protects the infant Jesus as they escape.

The right wing of the triptych (Figure 10 [to Mary's left]) features three scenes. The first two are Mary meeting Christ on the way to Calvary and the deposition from the Cross, both of which are rendered in moving, dramatic, human terms that the viewer understands through the figures' expressions and gestures. The third scene, the miraculous assumption of Mary into heaven, is mystical. All three scenes may be seen as traditional subjects that are often selected to stress the human relationship between mother and child or the theological role of Mary and her relation to Christ. Though Prokop could have selected any number of narratives, he selected episodes that show Mary's joy, sorrow, and glorious triumph. Could this selection be a subtle reminder of the mysteries of the rosary? It seems significant that the episodes begin with the annunciation, when Mary's earthly role as the Mother of God begins, and close with the assumption, when her time on earth ends and her role as queen of heaven begins.

When the wings of the triptych are closed during Lent (Figure 11), the viewer or devotee sees a stark presentation of the Cross, shroud, and instruments of the Passion. In contrast to the intense color of the open triptych, Father Prokop achieved an expressive monumentality through extreme simplicity of shape and form as well as limited color.

The Frescoes

Standing in the nave of the church, looking toward the altar, the viewer's eyes are drawn toward a number of frescoes that stretch across the entire sanctuary (Figure 5).[28] Farthest to the right and placed over a side altar is a depiction of St. Emeric (c. 1007–1031 [Figure 12]). Be-

28 The fresco of *St. Emeric* (Figure 12) and its matching one of the *Sacred Heart* (Figure 13) on the opposite side of the sanctuary are each approximately 21 ft. 10 in. tall by 12 ft. 9 in. wide.

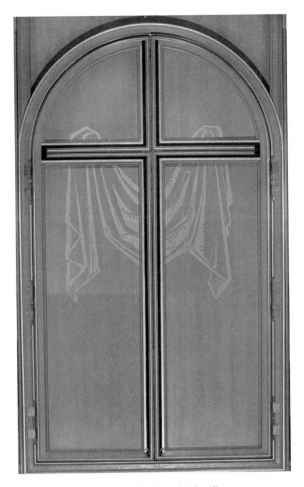

Figure 11: The Tripych (closed)

lieved to be the second son of St. Stephen, he was the only son to reach adulthood. He was named after his uncle, Holy Roman Emperor, St. Henry II (972–1024)—Emeric is the Hungarian form of Henry. As noted, St. Gellért served as his tutor.

He seems to have married in 1022, although his wife is not definitely identifiable. Intended by his father to be his successor, Emeric was tragically killed in a boar hunt at about age 23. He was canonized in 1083, on the same day as his father and his tutor.

Just as in the Our Lady of Hungary fresco, Emeric is traditionally depicted as a knight surrounded by lilies, wearing armor, and holding a sword and shield. Here, St. Emeric holds the coat of arms of the House of Arpad in his left hand. He stands in the middle of the fresco with a green-blue-faceted halo surrounding his head. Behind him is a collage of American-themed landscape scenes. To the viewer's left, an airplane flies over the Manhattan skyline and above it is a map of North America. To the viewer's right, Father Prokop depicted the Statue of Liberty, the U.S. Capitol, and Our Lady of Hungary Church. Under St. Emeric are the words *Sanctus Emericus* (Holy Emeric) and below that *Americus Patronus* (Patron of America). To the right are the words *Dux Hungarias* (Hungarian Duke). At the bottom of the fresco are the seal of the United States, on the left, balanced by the seal of the Vatican on the right. Undoubtedly, Prokop placed these seals to symbolize the faith of Hungarian-American Catholics as well as to thank the parishioners of Our Lady of Hungary parish, specifically, for aiding the Hungarian refugees.

Many Hungarians believe the Italian explorer Amerigo Vespucci (1454–1512) was named after Emeric, partially because the Latinized form of Emeric is *Americus*.[29] Dr. Ildiko Csurgay[30] argued that since there is only one St. Emeric, Vespucci must have been named after him. In an article in which he discusses a number of different possible origins for the name America, besides that of Amerigo Vespucci, Jonathan Cohen notes that the name Emeric was quite popular through Europe under various regional adaptations and spellings. He adds that the birth certificate of Amerigo states he was named after his grandfather.[31] While Father Prokop may have known of the connections among St. Emeric, Vespucci, and America, it seems reasonable to believe that Msgr. Sabo wanted to stress this belief as a matter of local Hungarian pride.

29 Ildiko Csurgay, *In Memory of Rev. Péter Prokop*, South Bend, IN, 2008.
30 Ibid.
31 Jonathan Cohen, The Naming of America: Fragments We've Shored Against Ourselves, http://www.uhmc.sunysb.edu/surgery/america.html.

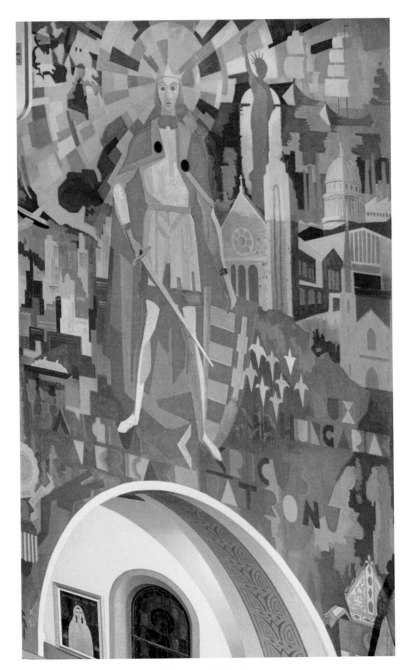

Figure 12: St. Emeric

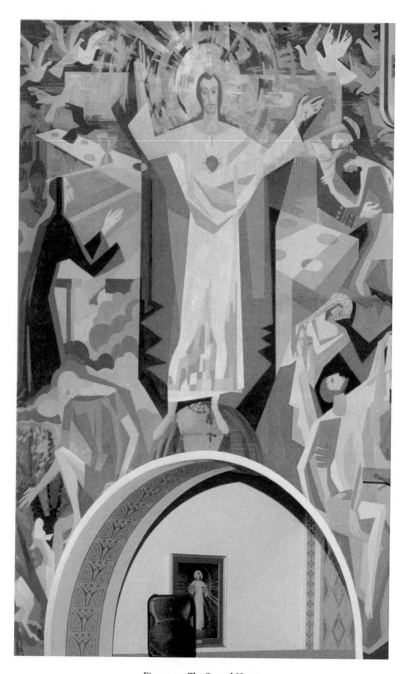

Figure 13: The Sacred Heart

Balancing St. Emeric, on the left, over the side chapel, is a fresco of the Sacred Heart of Jesus (Figure 13). The main figures in both frescoes are dressed in white, symmetrically placed, and surrounded by images associated with each of them. The major difference is that St. Emeric has a specific message that links Hungary to the United States while Christ's message is universal.

The Sacred Heart painting (Figure 13) is the most complex in the church, and in some ways the most puzzling. Msgr. Sabo thought the fresco of the Sacred Heart was Prokop's master-piece.[32] It seems to be a straightforward depiction of Christ with His Sacred Heart surrounded by four scenes: the Good Samaritan and the Prodigal Son on the right and the Good Shepherd and the mystic St. Margaret Mary Alacoque (1647–1690) on the left. Though her pro-file position makes it difficult to see her eye, Prokop emphasized her since she is the only person in the frescoes whose sclera and pupil the viewer can see. This suggests Christ coming to her in a vision and her acceptance of His message.

St. Margaret Mary was instrumental in founding devotions dedicated to the Sacred Heart.[33] Beginning December 27, 1673, when Margaret Mary was 26 years old, she believed Christ began to appear to her. Her visions continued over the next 18 months. In her visions, Christ said He chose her to establish devotions in honor of the Sacred Heart because she was willing to be absolutely obedient and endure any suffering to prove her love for Him. Her willingness to accept Christ's demands, pervades her writing.[34] She also said that Christ asked to be honored in the symbol of His heart of flesh. Since humankind is believed to be made in the image of God, and since the Son of God became man through the Incarnation, a limited symbol, such as the human heart, can represent the limitless love of God. Jesus lamented to St. Margaret Mary that, in return for His sacrifice, human-kind showed contempt and remained mired in sin. Therefore, Christ directed St. Margaret Mary to establish a set of devotions that includ-ed acts of reparation; frequent Communion, including Communion on the first Friday of the month for nine consecutive months; and to

32 Lockerbie, "Sermons Written in Paint," 10.

33 Pius XII, Encyclicals, *Haurietis Aquas,* On the Devotion to the Sacred Heart, May 15, 1956, http://w2.vatican.va/content/pius-xii/en/encyclicals/documents/hf_p-xii_enc_15051956_haurietis-aquas.html, paragraph 95, in which he acknowledges that Margaret Mary holds the most distinguished place in developing the devotions to the Sacred Heart.

34 Vincent Kerns (trans.), *The Autobiography of Saint Margaret Mary* (Westminster, MD: Newman Press, 1961). See, for example, pages 40–43 and 59–64 for St. Margaret Mary's descriptions of her absolute dependence on Christ.

keep the holy hour. In return for keeping these devotions to the Sacred Heart, Christ promised St. Margaret Mary His love, grace, and blessings as well as His help to resist sin.[35]

The Transfiguration, Resurrection, and *Parousia*

While the presence and depiction of St. Margaret Mary is straightforward, the depiction of Christ combines elements from different iconographic traditions. Christ stands on a globe or, perhaps, it could be better described as He hovers over the earth (Figure 13). The disparity in proportion between Christ and the other narrative figures, rather than being disconcerting, serves as a reminder of His humbling words: "Heaven and earth will pass away, but my words will not pass away" (Mt 24:35).[36] Christ is dressed in a white robe with a red cape, and an aureole emanates around His head. Looking more closely, it is possible to see the Cross, made from fragmented red shapes, behind Him. Christ's left arm is stretched out, and the blood trickling from the nail wound in the hand, which is a reminder of His suffering and death, connects Him to St. Margaret Mary, who kneels toward Him, in adoration and prayer. While the nail wound in the hand shows this to be the resurrected Christ, He bears no other physical scars from his Passion and Death. In depictions of the Resurrection, in European art, the triumphant, risen Christ is often shown holding a standard, usually one that is either white or with a red cross against a white background. Here, He holds neither. However, the luminous whiteness of His robe and the surrounding aureole that evokes the sun suggests Prokop may be referring to the Transfiguration.

In the three synoptic Gospels, immediately before narrating the Transfiguration, Mark, Matthew, and Luke narrate the same events: Peter identifies Jesus as the Messiah and the conditions of discipleship, and Christ reveals His coming Passion, Death, and Resurrection, and foretells the *Parousia* or His coming to judge all mankind at the end of time (Last Judgment).[37]

35 Kerns (trans.), *The Autobiography of Saint Margaret Mary*, 44 and 78.

36 United States Conference of Catholic Bishops (USCCB), Matthew, Chapter 24, http://www.usccb.org/bible/matthew/24. See also Mk 13:31, Lk 21:33. Christ's words also echo those found in Is 51:6.

37 In Mt 16: 21, Christ foretells his Passion and Resurrection; in Mt 16: 27–28, He foretells the Last Judgment. These immediately precede the narrative of the Transfiguration in Mt 17: 1–8 and, once again, in Mt 17:9, Christ explicitly relates the Transfiguration with the Resurrection. Mark 8:31 narrates Christ's prediction of His Passion, Death, and Resurrection; 9:1 mentions the Last Judgment and, in 2–8, narrates the Transfiguration. Luke 9:22–27 talks about the Passion, Resurrection, and Last Judgment while 28–36 narrates the Transfiguration. In 2 Peter 1:16–18, the apostle Peter describes

In the Transfiguration, each evangelist describes Christ as physically altered. Though they offer different visual, even painterly, imagery for the Transfiguration,[38] their language depicts the transfigured Christ as radiant, glorious, and enveloped in light. Christians believe that the Transfiguration reveals Christ to be the Son of God.

The Transfiguration reveals for a moment—and in diminished brilliance—the glory of God, and predicts both the Resurrection and the Parousia. This is confirmed since Mark and Matthew write that Jesus warned the three apostles, as they were walking down the mountain, not to reveal what they had just witnessed until "the Son of Man" had risen from the dead.[39] Thus, the evangelists direct the reader, or in earlier times, the listener, to link the Transfiguration with the Resurrection and the Parousia.

There is a strong connection between the Transfiguration and the Last Judgment. The symbolism of the Transfiguration—going up a mountain, the dazzling whiteness, the brightness of His face, the sense of glory—suggests the End of Days and Last Judgment. Besides the three synoptic Gospels, the pseudoepigraphic 2 Peter 1:16–18 refers to the Transfiguration as written by an eyewitness. Prokop may have used it as his source. Furthermore, the writer of the epistle does not mention details found in the synoptic accounts: he does not name James and John, and he leaves out the presence of Moses and Elijah.[40] In 2 Peter 1:12, the author states that he is writing to remind them of truths they already know. Similarly, Prokop used stripped-down depiction—not too detailed—to tell the narrative of the Transfiguration and to direct the faithful to contemplate the relation of the Transfiguration, Resurrection, and Parousia. Thus, a summary of 2 Peter is in accord with Prokop's fresco at Our Lady of Hungary Church.

the Transfiguration as an eyewitness. The events just preceding the Transfiguration are found in Mk 8:27–38 and 9:1; Mt 16:13–28; and Lk 9:18–27.

38 USCCB, Matthew, Chapter 17, http://www.usccb.org/bible/matthew/17:5, "And he was transfigured before them; his face shone like the sun and his clothes became white as light" (Mt 17:2); Ibid., Luke, Chapter 9, http://www.usccb.org/bible/mark/9:14, "While he was praying his face changed in appearance and his clothing became dazzling white" (Lk 9:29); Ibid., Mark, Chapter 9, http://www.usccb.org/bible/mark/9:14 and most visually, "And he was transfigured before them, and his clothes became dazzling white, such as no fuller on earth could bleach them (Mk 9:2-3). John Anthony McGuckin, *The Transfiguration of Christ in Scripture and Tradition* (Lewiston, NY: Edward Mellen Press, 1986), 1–19, is an excellent summary of the similarities, differences and relations among the three gospels.

39 Mk 9:9 and Mt 17:9.

40 2 Peter 1:16–18 also refers to the Transfiguration emphasizing he was an eyewitness. See for example, Dorothy Lee, *Transfiguration* (London and New York: Continuum, 2004), 88–97.

The Fathers of the Church explored the theme of the Transfiguration in numerous writings.[41] For example, they sought to define the transformation of Christ in the Transfiguration, often coming to the conclusion that the transfigured Christ only hints at the heavenly glories of God since no person could survive seeing God in all His Glory[42] and how mankind could become worthy to see the transfigured Christ. St. John Chrysostom (c. 349–407) explicitly linked the Transfiguration with the Last Judgment[43] and the Transfiguration with the Passion and the Resurrection.[44]

As noted, there is a strong written tradition that links these events, but there is not a strong tradition of visual imagery that links these episodes in the history of art. Though Prokop may not have explicitly depicted the Transfiguration, Resurrection, and Parousia, an awareness of each one's relation to the other certainly enriches our understanding of the painting and would have been readily understandable to believers in the early Church.

Similar to Mary in the triptych, Christ is iconic, which recalls Orthodox religious painting, and describes Him as the central figure around which themes and beliefs are revealed.[45] As noted, Matthew, Mark, and Luke explicitly link the Transfiguration with the Last Judgment as did the Fathers of the Church, such as St. John Chrysostom, who wrote:

> But if we will, we also shall behold Christ, not as they then on the mount, but in far greater brightness. For not thus shall He come hereafter. For whereas then, to spare His disciples, He discovered

41　McGuckin, *The Transfiguration of Christ in Scripture and Tradition*, contains translations of 31 texts by the Fathers of the Church, ranging from the 2nd to the 12th century, in which various aspects of the Transfiguration are discussed. McGuckin summarizes the patristic writings, 99–125. Andreopoulos, *Metamorphosis The Transfiguration in Byzantine Theology and Iconography*, 37, comments that McGuckin's list is good but not exhaustive.

42　McGuckin, *The Transfiguration of Christ in Scripture and Tradition*, 169–170, quotes and summarizes Gregory Nazianzen, who defined God as overwhelming light. This concept also goes back to the Old Testament. In Ex 33, 18–23, God says no human can survive seeing His full brilliance.

43　New Advent, Homilies on Matthew (Chrysostom), Homily 56 on Matthew, 7, http://www.newadvent.org/fathers/2001.htm.

44　Ibid., Homily 57 on Matthew, 2, http://www.newadvent.org/fathers/200157.htm.

45　Thomas F. Matthews, *Byzantium From Antiquity to the Renaissance*, Perspectives, Vol. 3 (New York: Harry N. Abrams, Inc., 1998), 122, argues that the depiction of the Transfiguration is a Byzantine or Orthodox subject that was adopted by Western Christianity. See also Gertrud Schiller (trans. Janet Seligman), *Iconography of Christian Art I* (Greenwich, CT: New York Graphic Society, 1971), 146.

so much only of His brightness as they were able to bear; hereafter He shall come in the very glory of the Father, not with Moses and Elias only, but with the infinite host of the angels, with the archangels, with the cherubim, with those infinite tribes, not having a cloud over His head, but even heaven itself being folded up.[46]

Thus, it is appropriate that Christ stands in front of a banquet table, which is reminiscent of the Last Supper and serves as a symbol of the eternal feast to which Christ has invited all mankind through His Death and Resurrection. This idea of banquet theology is found in Is 25:6–9.

> On this mountain the LORD of hosts
> will provide for all peoples
> A feast of rich food and choice wines,
> juicy, rich food and pure, choice wines.
> On this mountain he will destroy
> the veil that veils all peoples,
> The web that is woven over all nations.
> He will destroy death forever.
> The Lord GOD will wipe away
> the tears from all faces;
> The reproach of his people he will remove
> from the whole earth; for the LORD has spoken.
> On that day it will be said:
> "Indeed, this is our God; we looked to him, and he saved us!
> This is the LORD to whom we looked;
> let us rejoice and be glad that he has saved us!"[47]

Christ seems to have taken sheer enjoyment in food, wine, and feasting. Luke not only mentions 14 occasions when Christ dined, but notes in 7:34: "The Son of Man came eating and drinking and you said, 'Look, he is a glutton and a drunkard, a friend of tax collectors and sinners.'"[48] In Lk 14: 12–24, Christ used banquet imagery that derived from the Jewish tradition of hospitality and social obligation to define His message of salvation.

46 New Advent, Homilies on Matthew (Chrysostom), Homily 56 on Matthew, 7, http://www.newadvent.org/fathers/2001.htm.

47 USCCB, Isaiah, Chapter 25: 6-9, http://www.usccb.org/bible/isaiah/25.

48 Ibid., "Luke, Chapter 7," http://www.usccb.org/bible/luke/7

Then he said to the host who invited him, "When you hold a lunch or a dinner, do not invite your friends or your brothers or your relatives or your wealthy neighbors, in case they may invite you back and you have repayment. Rather, when you hold a banquet, invite the poor, the crippled, the lame, the blind; blessed indeed will you be because of their inability to repay you. For you will be repaid at the resurrection of the righteous."

One of his fellow guests on hearing this said to him, "Blessed is the one who will dine in the kingdom of God." He replied to him, "A man gave a great dinner to which he invited many. When the time for the dinner came, he dispatched his servant to say to those invited, 'Come, everything is now ready.' But one by one, they all began to excuse themselves. The first said to him, 'I have purchased a field and must go to examine it; I ask you, consider me excused.' And another said, 'I have purchased five yoke of oxen and am on my way to evaluate them; I ask you, consider me excused.' And another said, 'I have just married a woman, and therefore I cannot come.' The servant went and reported this to his master. Then the master of the house in a rage commanded his servant, 'Go out quickly into the streets and alleys of the town and bring in here the poor and the crippled, the blind and the lame.' The servant reported, 'Sir, your orders have been carried out and still there is room.' The master then ordered the servant, 'Go out to the highways and hedgerows and make people come in that my home may be filled. For, I tell you, none of those men who were invited will taste my dinner.'"[49]

Christ proclaims the universality of His invitation and emphatically notes that anyone who refuses the invitation cannot be saved. To those wishing to be saved, Mk 1:15 states: "This is the time of fulfillment. The kingdom of God is at hand. Repent, and believe in the gospel."[50]

Prokop chose biblical passages that exemplify attributes associated with the Sacred Heart. The narratives selected also reflect ideas discussed and proclaimed at Vatican Council II. Though Father Prokop dated his work 1961, and Vatican Council II began the following year, the ideas depicted in the Sacred Heart fresco had been discussed earlier by both Father Prokop and Msgr. Sabo. In essence, these ideas were

49 USCCB, Luke, Chapter 14, http://www.usccb.org/bible/luke/14.
50 Ibid., Mark, Chapter 1, http://www.usccb.org/bible/mark/1.

focused on defining penance[51] as composed of both conversion[52] and reconciliation.[53] While conversion may be defined as converting from one religion or denomination to another, it also suggests the transformative recognition of an indiviual's sins or of being outside of God's grace and the Roman Catholic community. Reconciliation completes the conversion since through it the repentant becomes reunited with God and rejoins the community. The Gospels offer numerous examples of conversion and reconciliation. Luke 23:39–43 relates what is perhaps the best-known narrative in the story of the good thief.

> Now one of the criminals hanging there reviled Jesus, saying, "Are you not the Messiah? Save yourself and us." The other, however, rebuking him, said in reply, "Have you no fear of God, for you are subject to the same condemnation? And indeed, we have been condemned justly, for the sentence we received corresponds to our crimes, but this man has done nothing criminal." Then he said, "Jesus, remember me when you come into your kingdom." He replied to him, "Amen, I say to you, today you will be with me in Paradise."[54]

The parable of the Prodigal Son (Lk 15:11–32) also emphasizes submission and redemption. It is significant that the Prodigal Son is placed closest to the eternal banquet table since it directly elucidates Christ's words about bringing the poor and abandoned. The parable of the Good Samaritan is also found in Lk 10: 29–37. While it is usually understood as an example of charity, St. Augustine (354–430), among other theologians, interpreted it as symbolizing Christ as the Good Samaritan who saves the sinner.

Finally, the metaphor of Christ as the Good Shepherd—the One who knows His sheep and will lay down His life for His sheep—is found in Mt 18:12–14 and Lk 1:1–7, but the most extensive treatment

51 J[ames]. Dallen, "Penance, Sacrament of, " New Catholic Encyclopedia (2nd ed.) (Detroit and Washington, D.C.: Thompson/Gale and The Catholic University of America, 2003).

52 F[rancis] J. Molony, "Conversion, I In the Bible." New Catholic Encyclopedia (2nd ed.) (Detroit and Washington, D.C.: Thompson/Gale and The Catholic University of America, 2003). R[ichard] T. Lawrence, "Conversion, II (Theology of)," New Catholic Encyclopedia (2nd ed.) (Detroit and Washington, D.C.: Thompson/Gale and The Catholic University of America, 2003).

53 Gerhard Sauter, "Reconciliation," The Encyclopedia of Christianity, vol. iv, P-Sh (ed. Erwin Faulbush, et. al., trans. Geoffrey W. Bromiley) (Grand Rapids, MI. : Wm. B. Eerdmans ; Leiden, Netherlands : Brill, 1999–2008), 504–506.

54 United States Conference of Catholic Bishops, "Luke, Chapter 23," http://www.usccb.org/bible/luke/23.

is found in the Gospel of John 10:1–21.[55] The metaphor of Christ as the Good Shepherd is among the oldest traditions of visual imagery in Christianity. The theme was popular and can be found in the catacombs,[56] when adherents often had to practice their religion in secret. It remained popular after 313 when the Roman emperors Constantine I (272–337) and Licinius (c. 263–325) issued the Edict that procaimed freedom of religion for all faiths in the empire.

The Sacred Heart

Both Msgr. Sabo and Father Prokop surely knew the encyclical *Haurietis Aquas, On the Devotion to the Sacred Heart* that Pope Pius XII published on May 15, 1956. The encyclical is a detailed examination and strong defense of the devotion to the Sacred Heart. While Msgr. Sabo may have wanted this subject as inspiration for his parishioners, since he was the pastor, it also seems credible that Father Prokop selected the Sacred Heart and the specific narratives because they exemplified community, which necessarily includes ways to remain faithful, to rejoin, and to be accepted back. As already noted, Father Prokop agreed to come to Our Lady of Hungary Church in thanksgiving for efforts made by the parish community on behalf of Hungarians during the Uprising of 1956.

The four evangelists or the writers of the Gospels are placed on two short walls next to the nave: St. Luke and St. John on the right (Figure 15) and St. Matthew and St. Mark on the left (Figure 14).[57] Their presence indicates that their writings are records of the words and deeds of Christ that serve to guide humankind.

On the side walls of the sanctuary are figures who illustrate Psalm 150 (Figure 16).[58] The text of the psalm reads:

55 Passages in the Old Testament include narrative, description, and metaphor. In Genesis 4:3–12, the well-known story of Cain and Abel is recounted, which embodies the age-old antagonism between the sedentary farmer and the nomadic shepherd as well as symbolizes the humility of faith that triumphs over the pride of self-righteousness. Other passages in the Old Testament also refer to shepherds. In Gn. 31: 38–41, Jacob's description suggests the hard life of a shepherd. In Ez 34: 1–31, the evil shepherds who have abandoned His flock are reviled, and God's determination that David will be the true shepherd that takes care of His flock is revealed. In Jer 23:1–4, a contrast is drawn between the evil shepherds and those who are righteous. However, perhaps the best-known reference to shepherds is in Psalm 23, in which God is portrayed as the shepherd who feeds, leads, and comforts the sheep of His flock.

56 Bridgeman Images, *The Good Shepherd* (fresco), Creator Roman (3rd century AD), Location Catacombs of Priscilla, Rome, Italy, https://www.bridgemanimages. com/en-GB/asset/419401/roman-3rd-century-ad/the-good-shepherd-fresco.

57 Each fresco of the evangelists is approximately 23 ft. 2 in. tall x 6 ft. 10 in.

58 The frescoes of Psalm 150 are approximately 20 ft. 8 in. tall on side walls that

Hallelujah!
Praise God in his holy sanctuary;
give praise in the mighty dome of heaven.
Give praise for his mighty deeds,
praise him for his great majesty.
Give praise with blasts upon the horn,
praise him with harp and lyre.
Give praise with tambourines and dance,
praise him with strings and pipes.
Give praise with crashing cymbals,
praise him with sounding cymbals.
Let everything that has breath
give priase to the LORD!
Hallelujah![59]

Father Prokop depicts 12 angels, arranged in 4 groups of 3 to illustrate the 150th psalm. He arranged the angels with their instruments and singing to interpret and capture the grandeur of the psalm. The angels dominate the composition through their sheer scale and stance over bright, flowing colors that suggest abstracted landscapes that are in front of bands of static, brilliant color. The compositions of each group and the stances of the angels once again suggest that Father Prokop looked at and adapted ideas from Byzantine painting. The middle angel in each group swings a censor to suggest praising the Lord in His Holy places. The phrasing suggests God's holy place is everywhere under the dome of heaven or all of earth. The other two angels in each group either play an instrument or sing in praise of God. Looking at the two groups on the left side of the sanctuary, in the one closest to the congregation, Prokop depicted one angel playing a horn and the other holding a stringed instrument. In the group farther back, he depicted an angel holding pipes and another angel holding a harp or lyre-like instrument. On the right side, in the closer group, both angels sing. In the rear group, one angel plays a tambourine and the second holds cymbals.

The last of the psalms, Psalm 150, is a series of exhortations to praise God. In the first two lines it is stated where to praise Him. In the next two lines the reasons for praising God are proclaimed: for Jews, for saving ancient Israel during critical moments in its history; for Christians, for providing Christ as the means for salvation. Last,

are about 20 ft. 10 in. long. However, the frescoes on the side walls are not continuous, but have about a 3 ft. gap in the middle. Therefore, the painted surface is about 17 ft. 10 in. Each of the frescoes on the back wall is approximately 20 ft. 8 in. tall by 18 ft. wide.

59 USCCB, Psalms, Chapter 150, http://www.usccb.org/bible/psalms/150.

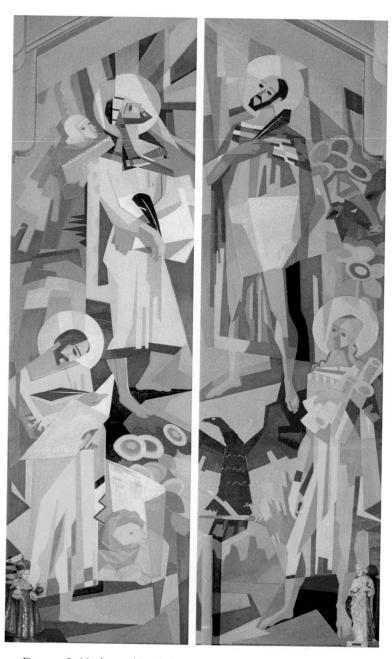

Figure 14: St. Matthew and St. Mark *Figure 15: St. Luke and St. John*

Figure 16: Figures Illustrating Psalm 150

the ways and means by which God may be praised are offered: with instruments, through music, and through dance.

From the earliest days of the Church, writers have symbolically identified instruments with aspects of human behavior. The trumpet, for example, represents the contemplative mind whereas the harp is associated with the busy mind that is excited by Christ, or, since the harp is made of wood, it should remind us of the Cross.[60] The psalm closes with the awe-inspiring universal command that every spirit (or, as it sometimes is translated, "all things that breathe") should praise God. Psalm 150 has been seen as closing one part of the psalms (psalms 107 through 150) and as summarizing the entire psalter.[61]

Though it is possible to cite numerous illustrations of angels and saints singing or playing music to praise the glory of God, there are seemingly few images that specifically illustrate Psalm 150.[62] The joyous praise of God found in Psalm 150 is certainly appropriate for a church, specifically for a choir. Traditionally, Psalm 150 (along with psalms 148 and 149) was recited during Lauds (Dawn Prayer), one of the prayers from the Liturgy of the Hours (also known as the Divine Office) that are said at specific times each day.

The apostles and early Christians continued the Hebrew practice of reciting psalms. Today, Lauds is one of three major prayers of the Liturgy of the Hours—the others being the Office or Readings (formerly Matins, for morning) and Vespers, for evening. The name Lauds derives from the recurrent use of the term *laudate* or praise throughout the three psalms. Since Lauds is recited at dawn, it welcomes the new day, reminds that Christ is the True Light of the world, and, metaphorically, brings to mind the Resurrection since this is the time of day Jesus rose from the dead.

For a Christian the first thought which should present itself to the mind in the morning, is the thought of God; the first act of his day should be a prayer. The first gleam of dawn recalls to our minds that Christ is the true Light, that He comes to dispel spiritual darkness, and to reign over the world. It was at dawn

60 Quentin F. Wesselschmidt, *Ancient Christian Commentary on Scripture Old Testament, Psalms 51–150* (Downers Grove, IL: InterVarsity Press, 2007), 429–430.

61 Walter Brueggemann and William H. Bellinger, *New Cambridge Bible Commentary Psalms* (New York: Cambridge University Press, 2014), 617–619.

62 One notable exception is the *Cantoria* (1431–1438) by Lucca della Robbia (1399/1400–1482) in the Museo dell'Opera del Duomo, Florence, Italy. While della Robbia's *Cantoria* has often been photographed and many examples can be found on the web, a good site is Florence Italy, *Cantoria* pt. 1, https://www.bluffton.edu/~sullivanm/italy/florence/duomomuseo/cantoriadellarobbia.html.

that Christ rose from the tomb, Conqueror of Death and of the Night. It is this thought of His Resurrection which gives to this office its whole signification. Lastly, this tranquil hour, before day has commenced, and man has again plunged into the torrent of cares, is the most favourable to contemplation and prayer. Liturgically, the elements of Lauds have been most harmoniously combined, and it has preserved its significance better than other Hours.[63]

On the back wall, behind the triptych, to the left, are three figures, seemingly a continuation of the musicians from Psalm 150 on the left (Figure 17). They hold either one continuous or two separate banners that read "*Patrona Hungariae*" (Protector of Hungary) and "*Ora Pro Nobis*" (Pray for Us). Again, on the back wall, balancing these figures on the right side of the sanctuary are three angels, who hold two separate banners (Figure 18). One bears the words "Patron Of The United States" and the other, "*Ora Pro Nobis*." The common and continuous landscape that unites the two scenes implies Prokop's intention that these two groups should be read as one message.

Parts of the frescoes on the rear wall are visible only when the triptych is closed during Lent. Appropriately, these bright images that symbolize the Passion and Crucifixion, complement the starkness of the triptych. Next to the angels bearing the banner "*Patrona Hungariae*" (Figure 17) are the veil St. Veronica used to wipe the face of Christ on his way to His Crucifixion, in front of the ladder used to raise the cross, the spear used to pierce his side, and the sponge soaked with gall or hyssop offered to Christ as He was dying. On the opposite side, next to the angels bearing the banner "Patron Of the United States" (Figure 18), from the top, the darkness that blots the sun during Christ's death, the crown of thorns, the Eucharistic chalice, the garments Christ wore, the nails used to affix Christ to the Cross, the dice the soldiers used to gamble for his clothes, the whip the soldiers used to scourge Christ, and reeds with which they struck Him as they paid mock homage.

Father Prokop integrates the figures from Psalm 150 on the side walls of the sanctuary with the angels on the back walls. The viewer tends to read the figures on the left and the figures on the right as two continuous paintings because all the figures are the same size and the curvilinear ground upon which they stand flows one into the other. He then uses the continuity of the landscape to connect Hungary and the

63 *Catholic Online: Inform, Inspire, Ignite*, http://www.catholic.org/encyclopedia/view.php?id=6899.

United States, metaphorically, while the banners explicitly place both countries under the protection of Mary. In effect, Father Prokop preaches that Mary, who protected Hungary throughout its history, now also protects the United States.

Similar to the other paintings, Prokop once again blends the traditional with the modern. For example, the stacking of the various symbols recalls Byzantine art while the simplification and abstraction shows Prokop's study of modern art from the early 20th century.

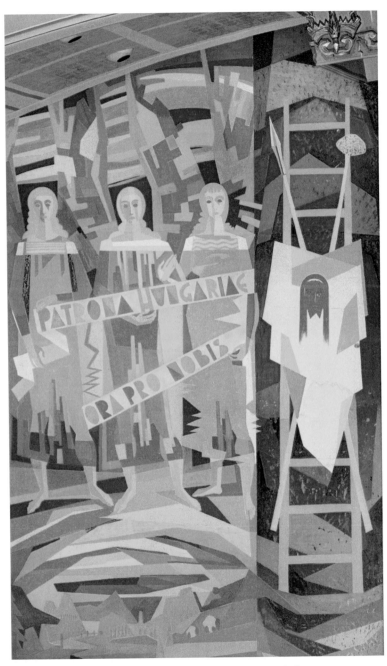

Figure 17: "Patrona Hungariae" "Ora Pro Nobis"

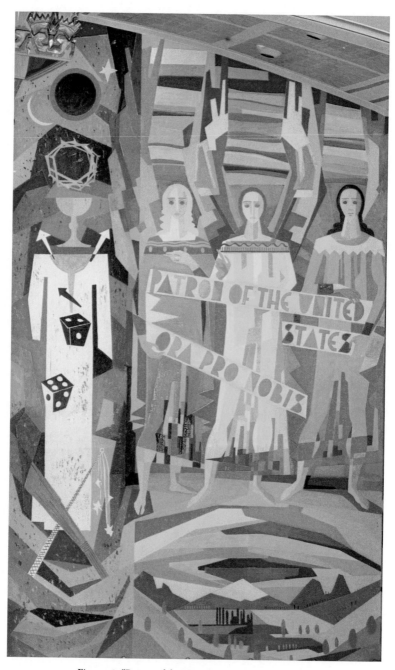

Figure 18: "Patron of the United States" "Ora Pro Nobis"

Chapter IV
Conclusion

Msgr. Sabo may have wanted paintings of unrelated subjects linked only through Father Prokop's modernistic style. It seems more reasonable that he wanted to express a coherent message. Admittedly, the links that compose the message can seem tenuous. Any interpretation must begin with the dominant role of Mary. On the triptych (Figure 6), Father Prokop stresses her traditional roles as human mother, heavenly intermediary, and protector of Hungary. The fresco of St. Emeric (Figure 12) explicitly connects Hungary and the United States. Less forcefully, it could be said, perhaps, that it symbolizes the relation between Hungary and the United States. In the two frescoes, the figures that hold banners near to Mary (Figures 17 and 18) expand her role of protector of Hungary to also being protector of the United States. However, this may have several interpretations, which are not contradictory. First, it may be seen as historical since the United States, at that time, was protecting the Crown of St. Stephen. Second, it may be read as a religious sentiment to remind parishioners that Mary looks over them in the United States as she did in Hungary or, to expand, third, it may be a theological wish to have Mary protect the United States as she does Hungary. Father Prokop may have meant to emphasize the third interpretation. Hungarians believed the Crown lands as well as its citizens belonged to Mary. The similarity of the American landscape to the Hungarian landscape suggests the same idea: the dedication of the country and its people to Mary.

Psalm 150 (Figure 16) may serve as a transition from the role of Mary to that of Christ in the Church. Since Christ's message is universal, it should be preached everywhere, outside in the world as well as within the physical confines of the church structure: Christ comes as the universal means of salvation. Finally, all should joyfully sing His praises. This directly relates to banquet theology found in Isaiah, when he writes that the saved exult and rejoice. Also, the four evangelists may be seen as the ones who actually communicated the Good News of Christ beyond the apostles and the earliest Christian communities.

Finally, the inclusion of the Sacred Heart (Figure 13) may honor the founding of Our Lady of Hungary Church. The Reverend Paul Miller C.S.C. came from the University of Notre Dame weekly, from the founding of the parish in 1916 until 1921, to address the spiritual needs of parishioners.[1] The founder of the C.S.C., Father Basil Moreau

1 Our Lady of Hungary Catholic Church and Parish, Our Church History…, http://ourladyofhungary.com/church/churchhistory.htm. On the website, Father Miller

(1799– 1873), consecrated the priests to the Sacred Heart and the order does stress devotion to the Sacred Heart. Furthermore, devotion to the Sacred Heart suggests following the active life inspired by Christ. The inclusion of this devotion in the frescoes may be due to Pope Pius XII's encyclical *Haurieti Aquas*, On the Devotion to the Sacred Heart. Both Msgr. Sabo and Father Prokop would have known this recent encyclical. In it, Pius argues that all Catholics, in fact, all Christians, need to repay Christ through sacrifice, devotion, and love for the divine love exhibited in the Sacred Heart. Devotion to the Sacred Heart may be seen as a universal devotion, including, of course, in Hungary.[2] Though the triptych of Mary is the most appealing of the paintings, it isn't difficult to understand why Father Prokop probably thought the Sacred Heart was the most important: it offered a path to salvation for the Catholic devotee.

is said to have filled the role and it is further stated that "In December of 1921, the Right Reverend Herman Alerding, Bishop of Fort Wayne, appointed Reverend Geza Gyorfy as Pastor at the mission and gave him the task of establishing a parish. Our Lady was an independent parish from that time. The new parish was not to be a national parish so a non-Hungarian priest was appointed to assist. This was the Reverend Charles Scholl." Jill Boughton, "Our Lady of Hungary: Bringing People Together in Three Languages," *Today's Catholic*, March, 21, 1993, 11.

2 Joseph Julius Charles Petrovits, *Theology of the Cultus of the Sacred Heart: A Moral, Dogmatic and Historical Study* (The Catholic University of America, Washington, D.C., 1917), 70.

Glossary

American Abstract Expressionism—The most important movement in American art after World War II and into the 1950s, it was based on elimination of subject, the emotional, the expressive, and often on spontaneity and improvisation. American Abstract Expressionist painters often worked on dramatically large canvases.

Arpads/Arpad Dynasty—The Árpáds or Arpads, named after Árpád (d. 907), considered the founder of Hungary, ruled the country from the ninth century until 1301. Both St. Stephen and St. Emeric were part of this dynasty.

Avant-garde—The vanguard or those artists who experiment with new and radical ideas in the arts.

Byzantine Roman Empire—It lasted from about 324 until 1453, when the Ottoman Turks conquered the city of Constantinople.

Cubism—A non-objective art style invented by Pablo Picasso and Georges Braque in the early 20th century. Cubism stressed abstract structure and fragmentation of natural forms as well as multiple viewpoints. Cubist artists also experimented with collage.

Divine Office—Daily public worship that is sometimes referred to as Liturgy of the Hours since it is recited at specific times while other liturgies can be recited throughout the day (see Liturgy of the Hours).

Edict of Milan of 313—The Edict of Milan of 313 empowered Christians and all other people with freedom of worship.

Expressionism—An early 20th century German art movement that rejected the natural for the emotional and the expressive.

Fauvism—The first major avant-garde movement in European art in the 20th century. Fauvists freed color from its traditional descriptive role to use it in expressive and emotional manners.

Fresco—The technique of painting on wet plaster, so that when the paint and plaster dry, the painting becomes part of the wall.

Glossary

Lauds—The morning office. Prior to 1911, Lauds included psalms 148–150, which begin with the Latin term laudate (Praise ye). Lauds are part of the Liturgy of the Hours or Divine Office.

Liturgy of the Hours—The practice of saying prayers at specific times of the day (see Divine Office).

Magyars—A people who probably originated in the area of the Ural Mountains and settled in Hungary late in the first millennium.

Matins—In the early church, Matins was the name for early morning services. Over time, an earlier service developed and that service became known as Matins. The original Matins became Lauds. Matins are part of the Liturgy of the Hours or Divine Office.

Minimalism—An art movement that began in the 1950s and sought to simplify and reduce radically each work of art to a few rigorously arranged elements.

Mosaics—Works made from small pieces of gold or silver-backed glass that act as mirrors, which reflect light back into the church, thus, flooding its interior with diffused light.

Novecento—The term translates as 900, but in the visual arts it means the art of the 1900s or the 20th century. Artists of this movement purposefully chose the term to echo earlier descriptions of divisions of Italian art, such as the *trecento*, which is the art of the 1300s, and the *quattrocento*, which is the art of the 1400s.

Parousia—The Second Coming of Christ in glory to judge humankind.

Pop Art—An art movement that began in the mid-1950s in England and in the late 1950s in the United States. This movement challenged the traditions of fine or high art by seeking inspiration from popular culture.

Psalms—Hymns of praise to God and pleas for His mercy. These 150 hymns have no apparent narrative order, and though ascribed to King David, they were probably written by a diverse collection of authors.

Psalter—The manuscript or book that contains the psalms.

Glossary

Pseudepigrapha—A book or writing that is falsely titled or falsely attributed to an author; a work written later but attributed to an earlier author.

Pseudepigraphic, pseudoepigraphical—A book or writing that is falsely titled or attributed to an author, a work written later but attributed to an earlier author having the characteristics of pseudepigrapha.

Synoptic Gospels—Mark, Luke, and Matthew are termed the synoptic Gospels because scholars can arrange their texts in columns to compare and contrast more easily the three Gospels. The evangelists tell many of the same narratives in the same order and often use very similar language. Mark is believed to be the earliest, which Luke and Matthew then used as the basis for their Gospels. Scholars disagree whether Luke and Matthew then used a second, unknown source, labeled Q, for what is common to them but not found in Mark or which writer looked to the other. Of course, there is material unique to Luke and to Matthew, which is usually labeled L and M.

Triptych—A three-panel painting that consists of a stable central panel flanked with a movable wing on the right and on the left.

Vespers—Evening services that are part of the Divine Office or the Liturgy of the Hours.

Bibliography

"Aba-Novák, Vilmos." Grove Art Online. Oxford Art Online. Oxford University Press. http://www.oxfordartonline.com/subscriber/article/grove/art/T00005.

"Activists." Grove Art Online. Oxford Art Online. Oxford University Press. http://www.oxfordartonline.com/subscriber/article/grove/art/T000384.

Alinari. Archives. http://www.alinariarchives.it/en/search?isPosBack=1&panelAdvSearch=opened&artista=Oppi,%20Ubaldo%20%281889-1946%29.

The American-Hungarian Federation. "The Treaty of Trianon: A Hungarian Tragedy—June 4, 1920." Summary. www.american-hungarianfederation.org/news_trianon.htm.

Andreopoulos, Andreas. *Metamorphosis: The Transfiguration in Byzantine Theology and Iconography*. Crestwood, NY: St. Vladimir's Seminary Press, 2005.

Berend, Ivan. *Decades of Crisis*. Berkeley, Los Angeles, and London: University of California Press, 1998.

Boughton, Jill. "Our Lady of Hungary: Bringing People Together in Three Languages." *Today's Catholic*, March, 21, 1993.

Bridgeman Images. *Fishermen of the Holy Spirit* (Oil on Canvas). http://www.bridgemanimages.com/en-GB/asset/702941.

———. *The Good Shepherd* (fresco). Creator Roman (3rd century AD). Location Catacombs of Priscilla, Rome, Italy. https://www.bridgemanimages.com/en-GB/asset/419401/roman-3rd-century-ad/the-good-shepherd-fresco.

Brueggemann, Walter, and William H. Bellinger. *New Cambridge Bible Commentary Psalms*. New York: Cambridge University Press, 2014.

Cantrell, Janice L. e-mail message to author, May 15, 2014.

Bibliography

Catholic Answers To Defend & Explain the Faith. www.catholic.com.

Catholic Architecture and History of Toledo, Ohio: A tribute to the treasure trove of ecclesiastical art and architecture in the Diocese of Toledo. January 30, 2008. St. Stephen, East Toledo. http://catholictoledo.blogspot.com/2008_01_01_archive.html.

Catholic Online: Inform, Inspire, Ignite. www.catholic.org.

Cohen, Jonathan. The Naming of America: Fragments We've Shored Against Ourselves. http://www.uhmc.sunysb.edu/surgery/america.html.

Cooper, Philip. "MA group." Grove Art Online. Oxford Art Online. Oxford University Press. http://www.oxfordartonline.com/subscriber/article/grove/art/T053170.

Csurgay, Ildiko. *In Memory of Rev. Péter Prokop*. South Bend, IN, 2008.

Dallen, J[ames]. "Penance, Sacrament of." *New Catholic Encyclopedia* (2nd ed.). Detroit and Washington, D.C.: Thompson/Gale and The Catholic University of America, 2003.

Dolan, Jay P. *The American Catholic Experience: A History from Colonial Times to the Present*. Notre Dame, IN: University of Notre Dame Press, 1992.

Dumbarton Oaks Research Library and Collection 75. The Uncovering of the Mosaics of Hagia Sophia in Constantinople: From a letter written to Mildred Barnes Bliss on October 11, 1936. http://www.doaks.org/library-archives/dumbarton-oaks-archives/royall-tyler-2013-excerpts-from-letters-about-his-travels/the-uncovering-of-the-mosaics-of-hagia-sophia-in-constantinople.

Faber, Erika Papp. "Prokop, Péter: Priest-Artist." *Magyar Studies of America: Magyar News Online*. June 2016, Issue 100. http://magyarnews.org/news.php?viewStory=1679.

Florence Italy, *Cantoria* pt. 1, https://www.bluffton.edu/~sullivanm/italy/florence/duomomuseo/cantoriadellarobbia.html.

Bibliography

Fraquelli, Simonetta. "Novecento Italiano." Oxford Art Online. http://www.oxfordartonline.com/subscriber/article/grove/art/T062914.

Gale, Matthew. "Oppi, Ubaldo." Grove Art Online. Oxford Art Online. Oxford University Press. http://www.oxfordartonline.com/subscriber/article/grove/art/T063656.

Glaser-Hille, Ildikó. "Magyarok Nagyasszonya: The Virgin Mary as a Symbol of Hungarian National Identity." https://www.academia.edu/2526883/Magyarok_Nagyasszonya_ The_Virgin_Mary_as_a_Symbol_of_Hungarian_National_Identity.

Hilsdale, Cecily J. "The Social Life of the Byzantine Gift: The Royal Crown of Hungary Re-Invented." *Art History*, 2008. http://onlinelibrary.wiley.com doi:10.1111/j.1467-8365.2008.00634.x/pdf.

Hoensch, Jörg (trans. Kim Traynor). *A History of Modern Hungary 1867–1986.* London and New York: Longman, 1988.

Ireneaus, Saint, Bishop of Lyon. *Five Books of St. Irenaeus of Lyons Bishop of Lyons Against Heresies.* Oxford: J. Parker, 1872. HathiTrust: 100337939, 294–95 and 494.

Jászi, Oscar. "Kossuth and the Treaty of the Trianon." *Foreign Affairs,* Oct 1933, vol. 12, Issue 1, 86–97.

Kalocsai Èrseki Kincstár. Prokop Péter életútja 1919–2003 (Prokopp Mária könyve alapján). http://kincstar.asztrik.hu/?q=content/prokop-peter-eletutja-1919-2003-prokopp-maria-koenyve-alapjan.

Kampis, Antal. *The History of Art in Hungary.* Budapest: Corvina Press, 1986.

Kelleher, Patrick J. *The Holy Crown of Hungary.* Papers and Monographs of the American Academy in Rome, vol. 13. Rome American Academy, 1951.

Kerns, Vincent (trans.). *The Autobiography of Saint Margaret Mary.* Westminster, MD: Newman Press, 1961.

Bibliography

Kobayashi, Hiromi, and Shiro Kohshima. "Unique morphology of the Human Eye." *Nature*, 6/19/1997, 767–768.

Kontha, S. "Aba-Novák, Vilmos." Grove Art Online. Oxford Art Online. Oxford University Press. http://www.oxfordartonline.com /subscriber/article/grove/art/T00005.

Kontler, László. *A History of Hungary: Millennium in Central Europe*. New York: Palgrave MacMillan, 2002.

Kosary, Dominic G., and Steven Bela Várdy. *History of the Hungarian Nation*. Astor Park, FL: Danubian Press, Inc., 1969.

Lawrence, R[ichard] T. "Conversion, II (Theology of)." *New Catholic Encyclopedia* (2nd ed.). Detroit and Washington, D.C.: Thompson/Gale and The Catholic University of America, 2003.

Lee, Dorothy. *Transfiguration*. New York, London: Continuum, 2004.

Library of Congress. Geograpy and Map Division. https://www.loc. gov/rr/geogmap/.

Lockerbie, Sarah. "Sermons Written in Paint." *The South Bend Tribune*. November 4, 1962.

Magyar Katolikus Lexikon. K: "Kontuly." http://lexikon.katolikus hu/ K/Kontuly.html.

Mansbach, S.A. *Standing in the Tempest, Painters of the Hungarian Avant-Garde 1908–1930*. Santa Barbara, CA: MIT Press and the Santa Barbara Museum of Art, 1991.

———. "Confrontation and Accomodation in the Hungarian Avant-Garde." *Art Journal*, XXXXVIIII, Spring 1990, 9–20.

Marosi, Ernö, et al. "Hungary." Grove Art Online. Oxford Art Online. Oxford University Press. http://www.oxfordartonline.com/ subscriber/article/grove/art/T039443.

Mathews, Thomas F. *Byzantium: from Antiquity to Renaissance*. Perspectives: Vol. 3. New York: Harry N. Abrams, Inc., 1998.

Bibliography

McGuckin, John Anthony. *The Transfiguration of Christ in Scripture and Tradition*. Study in the Bible and Early Christianity: Vol. 9. Lewiston, NY: Edward Mellen Press, 1986.

MNG. Hungarian National Gallery. http://mng.hu/collection/friends-21120.

Molony, F[rancis] J. "Conversion, I In the Bible." *New Catholic Encyclopedia* (2nd ed.). Detroit and Washington, D.C.: Thompson/Gale and The Catholic University of America, 2003.

Monotti, Francis. "Young Italy Speaks." *New York Times*, June 23, 1929.

Németh, Lajos. *Modern Art in Hungary*. Budapest: Corvina Press, 1969.

New Advent. Dedicated to the Immaculate Heart of Mary. http://www.newadvent.org/.

"Oppo, Cipriano Efisio." *Allgemeines Künstlerlexikon: Die bildenden Künstler von der Antike bis zur Gegenwart, XXVI*. Leipzig: Veb. E. A. Seeman Verlag, 1970: 34.

"Oppo, Cipriano Efisio." *Benezit, Dictionary of Artists*, X. Paris: Gründ, 2006: 626–627.

Our Lady of Hungary Catholic Parish and School. 2014. http://ourladyofhungary.com/church/churchhistory.com.

Our Lady of Hungary Church 1949 (Magyarok Nagyasszonya Hitközség).

Panoramio: Google Maps, Kalocsa, Nagyboldogasszony főszékesegyház belseje/St. Mary cathedral interior. http://www.panoramio.com/photo/58032892.

Parachin, Victor M. "Christmas with St. Francis." *Messenger of St. Anthony*. http://www.messengersaintanthony.com/messaggero/pagina_articolo.asp?IDX=529IDRX=144.

Bibliography

Petrovits, Joseph Julius Charles. *Theology of the Cultus of the Sacred Heart: A Moral, Dogmatic and Historical Study.* Washington, DC: The Catholic University of America, 1917.

Pius XII. Encyclicals. *Haurietis Aquas.* On the Devotion to the Sacred Heart. May 15, 1956. http://w2.vatican.va/content/pius-xii/en/encyclicals/documents/hf_p-xii_enc_15051956_haurietis-aquas.html.

Rudolph, L.C. *Hoosier Faiths: A History of Indiana's Churches & Religious Groups.* Bloomington: Indiana University Press, 1995.

Sauter, Gerhard. "Reconciliation." *The Encyclopedia of Christianity,* iv, P-Sh (ed. Erwin Faulbush, et. al., trans. Geoffrey W. Bromiley). Grand Rapids, MI: Wm. B. Eerdmans; Leiden, Netherlands: Brill, 1999–2008: 504–506.

Scherer, Darlene (ed. Karen Rasmussen). *The Hungarian-Americans of South Bend.* Ethnic Heritage Studies Program. Indiana University South Bend, 1975.

Schiller, Gertrud (trans. Janet Seligman). *Iconography of Christian Art I.* Greenwich, CT: New York Graphic Society, 1971.

The South Bend Tribune. "Church Ready for Dedication." December 15, 1949.

Sükösd. "Prokop Péter Ès a Híres Sükösdi Falfreskó." http://www.sukosd.hu/?module=news&action=show&nid=63370.

Szostak, John M. (complied by Attila L. Simontsits). "America's Acquisition of St. Stephen's Crown." *The Last Battle for St. Stephen's Crown.* Toronto: Weller Publishing, 1983.

"Treaty of Friendship, Conciliation and Arbitration Between Hungary and Italy. Signed at Rome, April 5, 1927." http://www.forost.ungarisches-institut.de/pdf/19270405-1.pdf.

"Treaty of Trianon. Treaty of Peace Between The Allied and Associated Powers and Hungary and Protocol and Declaration, Signed at Trianon June 4, 1920." http://wwi.lib.byu.edu/ index.php/Treaty_of_Trianon.

Bibliography

United States Conference of Catholic Bishops. Bible. *The New American Bible, Revised Edition* (NABRE). http://www.usccb.org./bible/.

Várdy, Steven Bela. *Clio's Art in Hungary and in Hungarian-America.* East European Monographs: No. 179. Boulder, New York: Distributed by Columbia University, 1985.

————. *Historical Dictionary of Hungary.* Lanham, MD: Scarecrow Press, 1997.

Wesselschmidt, Quentin F. *Ancient Christian Commentary on Scripture Old Testament, Psalms 51–150.* Downers Grove, IL: InterVarsity Press, 2007.

Wikiwand. Basilica di Sant'Antonio di Padova. "Cappella di San Francesco." http://www.wikiwand.com/it/Basilica_di_Sant' Antonio_di_Padova.

Yale Law School. Lillian Goldman Law Library in memory of Sol Goldman. The Avalon Project: Documents in Law, History and Diplomacy. "8 January, 1918: President Woodrow Wilson's Fourteen Points." http://avalon.law.yale.edu/ 20th_century/ wilson14.asp.

Notes

Made in the USA
Middletown, DE
02 July 2016